Published on the occasion of the exhibition
Boom: Art and Design in the 1940s
Philadelphia Museum of Art
April 12–September 1, 2025

The exhibition was made possible by the Annenberg Foundation Fund for Major Exhibitions, Laura and William C. Buck Endowment for Exhibitions, Jill and Sheldon Bonovitz Exhibition Fund, Lois G. and Julian A. Brodsky Installation and Exhibition Fund, Gloria and Jack Drosdick Fund for Special Exhibitions, Zoë S. Pappas, Barbara A. Podell and Mark G. Singer, and other generous supporters.

All exhibitions at the PMA are underwritten by the Annual Exhibition Fund. Generous support was provided by Andrea Baldeck, M.D.; Julia and David Fleischner; Amy A. Fox and Daniel H. Wheeler; Mrs. Henry F. Harris; Robert Hayes; Mark W. Strong and Dana Strong.

Support for this accompanying publication was provided by the Center for American Art at the Philadelphia Museum of Art.

Produced by the Publishing Department
Philadelphia Museum of Art
2525 Pennsylvania Avenue
Philadelphia, PA 19130-2440
philamuseum.org

Distributed by Yale University Press
302 Temple Street
P.O. Box 209040
New Haven, CT 06520-9040
yalebooks.com/art

Organizing editors:
Alison McDonald and Jessica Todd Smith
Project manager and editor:
Kathleen Krattenmaker
Publication coordinators:
Vittoria Ciaraldi and Isabella Szyfer
Proofreaders: Mary Cason and Sarah Noreika
Production: Richard Bonk
Image research and acquisition: Lily F. Scott
Design: Paul Neale and Carole Courtillé, Graphic Thought Facility
Color separations and printing: Verona Libri, Italy

Text and compilation
© 2025 Philadelphia Museum of Art

All rights reserved. No part of this publication may be reproduced or transmitted in any form or by any means, electronic or mechanical, including photocopying, recording, or any other information storage or retrieval system (beyond that copying permitted by Sections 107 and 108 of the US Copyright law and except by reviewers for the public press), without permission in writing from the publisher.

Every attempt has been made to locate the copyright holders of the works reproduced herein. Any omission is unintentional.

Front cover
 Paris couturier Robert Piguet's trouser ensemble with cape and gas mask, c. 1939–40. Photograph by Albert Harlingue © Albert Harlingue / Roger-Viollet (colorized with permission)
Front flap
 US government press photo of Irving Berlin aboard the USS *Arkansas*, July 25, 1944
Back flap
 Beauford Delaney, *Portrait of James Baldwin*, 1945 © Estate of Beauford Delaney by permission of Derek L. Spratley, Esquire, Court Appointed Administrator; Courtesy of Michael Rosenfeld Gallery LLC, New York
Back cover
 Orson Welles poses astride stacks of newspapers in a publicity photograph for his film *Citizen Kane*, 1941. Alamy Stock Photo

Library of Congress Control Number: 2024952980

ISBN 978-0-87633-306-8

Authorized Representative in the EU Details:
Easy Access System Europe, Mustamäe tee 50, 10621 Tallinn, Estonia, gpsr.requests@easproject.com

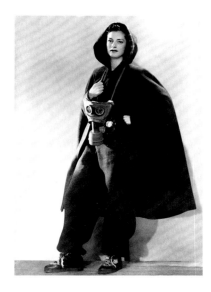

BOOM
Art & Design in the 1940s

Features

Director's Statement Sasha Suda . 2
A Look at the 1940s Jessica Todd Smith . 2

Features

The War A Conversation with Ken Burns . 8
The Poems of Anna Akhmatova Isabella Szyfer . 16
Cultural Renegades A Conversation with Christian McBride 28
Queer Connectivity Lily F. Scott . 36
Fashion During Wartime Alexandra Palmer . 46
Hollywood in the 1940s Steven Rea . 58
The Economies of War Frederic Murphy . 66
Fragments of Lost Histories A Conversation with Edmund de Waal 76

Curatorial Highlights

Witness to the War: Margaret Bourke-White on the Eastern Front Amanda N. Bock . . . 6
"Needles and Guns": Elsa Schiaparelli and America Dilys Blum 14
Unseeable Things: War, Technology, Photography Amanda N. Bock 26
Art in the Home: Painting by the Yard Dilys Blum . 32
Make It Do: American Modernist Jewelry Elisabeth Agro 34
From War to Peace: Horace Pippin on the Home Front Jessica Todd Smith 44
George Nakashima: Synthesis and Identity Elisabeth Agro 56
Genesis: Jackson Pollock and Lee Krasner Jessica Todd Smith 64

Notes . 78
Acknowledgments . 80

Works of the 1940s are a particular strength of the Philadelphia Museum of Art's collections across a wide and varied range of media. The exhibition *Boom: Art and Design in the 1940s* gives us an opportunity to share these exceptional holdings with our visitors, while also providing a snapshot of a critical decade in American history.

This publication is intended to enhance the visitor's experience of the era through a dynamic magazine-style format, with texts that provide vital social and cultural context—from music and film of the 1940s to poetry and economic history—for the works in the galleries. This format also presented an opportunity to bring voices from outside the museum into the conversation. We warmly thank Ken Burns, Christian McBride, and Edmund de Waal for their illuminating discussions with Alison McDonald, and Frederic Murphy, Alexandra Palmer, Steven Rea, and Isabella Szyfer for their engaging and enlightening texts.

Both the exhibition and publication were spearheaded by Jessica Todd Smith, director of Curatorial Affairs, who worked with colleagues throughout the museum to realize the project under a very tight timeline. I join her in thanking them for their contributions, and in extending special thanks to her chief collaborators and contributing authors at the museum: Elisabeth Agro, curator of modern and contemporary craft and decorative arts; Dilys Blum, senior curator of costume and textiles; Amanda N. Bock, assistant curator of photographs; Lily F. Scott, the project's exhibition assistant; H. Sumner Bridenbaugh, manager of Curatorial Affairs; and Ateret Sultan-Reisler, who provided valuable archival research while a fellow with the museum's Center for American Art.

This publication would not have come to fruition without the expertise of Kathleen Krattenmaker, director, and Richard Bonk, production manager, in the museum's Publishing Department. We also owe a big debt of gratitude to Alison McDonald for her crucial guidance in helping to conceptualize and formulate the publication at lightning speed, and to Paul Neale and Carole Courtillé of Graphic Thought Facility in London for its inspired design. Finally, we thank those who so generously provided the financial support essential to the realization of both the exhibition and this publication.

Sasha Suda, The George D. Widener Director and Chief Executive Officer, Philadelphia Museum of Art

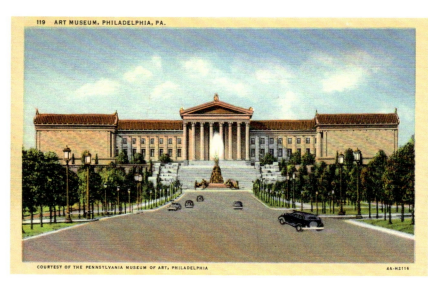

[1] Postcard of the Philadelphia Museum of Art in the 1940s

A Look at the 1940s

The title of this project plays on the multivalent meaning of the word "boom." The 1940s was a decade that witnessed major shifts in politics, science, economics, industry, the arts, and culture. It saw the booming economy in the United States that followed the economic depression that dominated the 1930s. There was an expansion of manufacturing and an explosion of creativity. America's baby boom had a lasting impact on global demographics. The decade also bore witness to World War II, the deadliest conflict in human history. The booms were both metaphorical and literal.

Throughout this tumultuous period, artists and designers brought new ideas to their work in all media. The Philadelphia Museum of Art is fortunate to have particularly rich holdings of 1940s art and design. As the curatorial team cast our nets into this wealth of material, we came up with over 24,000 items that were ripe for consideration for the exhibition that inspired this publication—from fashion and textiles, craft and design, to prints, drawings, photographs, painting, and sculpture—providing a snapshot of artistic production from the decade.

By examining the whole of the 1940s, rather than the more common focus on the postwar period, this project challenges the perception that creative pursuits ground to a halt during the first half of the decade on account of the war. So much was lost. The devastation was unspeakable. Infinite stories of grief and heartache from around the globe abound. At the same time, the impulses of seeking, striving, and finding a way forward persisted. Grief can coexist with other states of being, and this project is a testament to the spirit of creativity that flourished despite restrictions and adversity.

On the subject of restrictions, several notable considerations shaped the project. First, while World War II is a theme in the exhibition, there are relatively few works in the collection that deal with the war directly, and neither the exhibition nor this publication covers the conflict in all its aspects. The exhibition is about art of the moment, through which many, but not all, stories can be told.

We tried to build a wide-ranging checklist, including work by women, artists of color, and artists from outside the United States, as creativity crosses geopolitical boundaries. However, the museum's collections from the 1940s historically have focused on American artists and those who immigrated to the United States, and that proportional balance is reflected in the exhibition and the works of art featured in this publication. While the displacement of European artists and the importance of Latin American art are key themes, the museum's collection does not yet present an overview that is truly global in its scope.

The Philadelphia Museum of Art in the 1940s

In the first half of the decade, the museum felt the impact of the country's involvement in World War II. As employees left to support the war effort, some museum operations were disrupted and galleries were forced to close intermittently because of staffing shortages. Nevertheless, the museum's education efforts flourished with free children's classes, lectures, and films, and the collection continued to grow. [1]

Through most of the decade, the staff was led by a fairly consistent team. Fiske Kimball served as director from 1925 to 1955. Henri Marceau became a curator in 1929 and was associate director from 1937 until 1955, taking over as director after Kimball retired. Henry Clifford served in various curatorial capacities from 1930 until 1964. Another key member of the curatorial team was Carl Zigrosser, who was director of the Weyhe Gallery in New York in the 1920s and 1930s. The museum hired Zigrosser in December 1940, and he led the print department until his retirement in 1963. [4]

Henry P. McIlhenny was a curator at the museum from 1939 to 1964, though he also served in the United States Naval Reserve and spent time in the Pacific theater during the war. Having come from a wealthy family, he was content with a salary of a dollar a year. He had a castle in Scotland, eventually served as the chairman of the museum's board of trustees, and bequeathed his collection of French masterpieces to the museum. In a portrait of McIlhenny in his home, the artist Franklin Chenault Watkins included part of the painting *At the Moulin Rouge: The Dance* by Henri de Toulouse-Lautrec, a highlight of the museum's collection today. [2]

The museum's annual reports generally focus on the bright side of things and tend not to dwell too heavily on politics or current events. But Fiske Kimball's report of 1942 notably describes the fitness of the museum to withstand an attack:

> The Museum, situated on a plateau of rock, fortunately already possessed a subterranean store room which, by additional reinforcement and by heavy vault-doors, has been made into a strong-room which should be secure against a 1000-pound bomb. It is sufficiently large to receive, in a period of acute danger, about 200 irreplaceable objects of all classes.[1]

While the prose adopts a relatively cheerful tone, it nonetheless demonstrates the very real concern about war coming to the United States and the fear of violence that hovered over daily life throughout the conflict.

Kimball goes on to note that the design and construction of the museum building meant that it was "in an unusually favorable situation for continuing to maintain its displays and activities for the public." Visitors continued to appreciate the education and recreation provided by the museum, despite the rationing of rubber and gasoline, which apparently caused a general decrease in museum attendance in Philadelphia and elsewhere.[2] Attendance rose slightly in 1939 and 1941, flattened in 1942, dropped precipitously in 1943, and gradually began to recover in 1944.

During the 1930s the museum benefited from labor provided by the Works Progress Administration. Projects continued to move forward in the 1940s, despite the diversion of this workforce to other types of labor. The decade began with an inaugural exhibition in the new "Oriental Wing"—seven new galleries devoted to "the arts of Persia, China, and India"—in April 1940, and Henri Marceau mounted the museum's second *Sculpture International* (see p. 80).[3]

Activities slowed slightly in 1941, but the collection grew following the donation of the art critic and collector Christian Brinton's extensive library, archive, and art collection to the museum. [3] It was put on display along with an exhibition of "Russian Graphic Art" presented by the American Russian Institute, "conceived in good will and dedicated to the promotion of cultural relations and sympathetic understanding between the American people and the peoples of the Soviet Republics."[4] Parts of the Brinton collection were shown at twenty institutions between 1942 and 1946, when the US and the Soviet Union were allies in the fight against Nazi Germany.[5]

Despite the increasing involvement of the United States in the war after the Japanese attack on Pearl Harbor on December 7, 1941, and the subsequent gallery closures and diminished attendance, 1943 marked several milestones. The museum installed the great Neoclassical drawing room from Lansdowne House, London. Henry Clifford curated the groundbreaking exhibition *Mexican Art Today* in collaboration with Inés Amor, shifting attention from muralism in Mexico to easel painting. That same year the museum received the art collection of John D. McIlhenny (father of curator Henry P. McIlhenny), with its particularly strong holdings of Asian and Middle Eastern carpets. Perhaps an even greater windfall was the receipt of the extraordinary collection of Albert Eugene Gallatin.

A. E. Gallatin was an artist and collector who founded the Museum of Living Art at New York University in 1927, with the goal of providing the public with an opportunity to study "the most important and recent developments of Twentieth Century painting."[6] [6] When the lease there ended, Fiske Kimball pounced, and Gallatin's collection was on view at the Philadelphia Museum of Art within a matter of months. Curator Henry Clifford noted that the collection was formed "in the temporal and geographical interim between Versailles and Pearl Harbour," or approximately 1918–41, adding that its examples of Cubist, Constructivist, and abstract art were without peer in this country or abroad, and included several outstanding masterpieces in the history of painting.[7]

Highlights of the exhibition program of 1944 included the *Thomas Eakins Centennial*; *History of an American: Alfred Stieglitz, "291" and After*; and *Two Great Mexicans: Paintings by Velasco, Prints by Posada*. [7] There was still public demand for the recreation and relaxation the museum was offering, though there were several installations with titles that suggest that a visit

[2] Franklin Chenault Watkins, *Portrait of Henry P. McIlhenny*, 1941

[3] Nikol Schattenstein, *Adoration of Moscow (Portrait of Christian Brinton)*, 1932

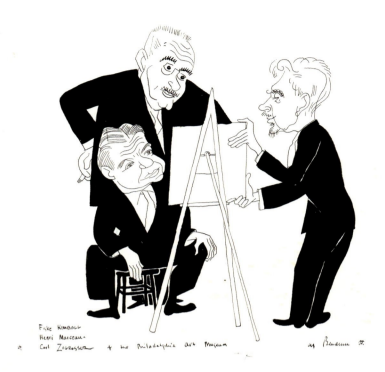
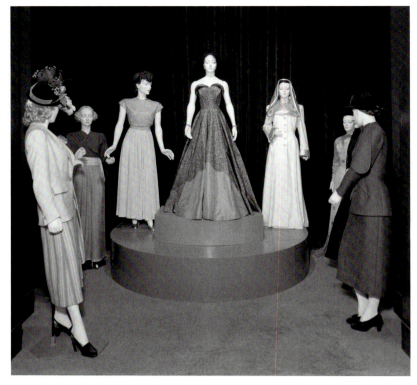
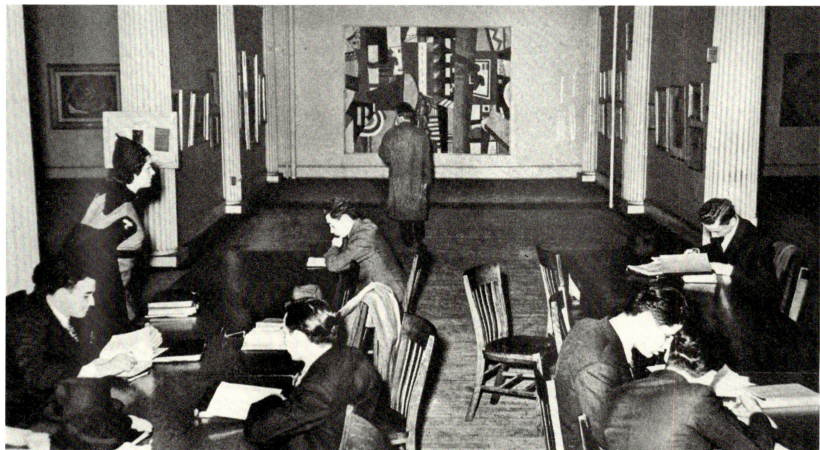

[4, top left] Alfred Bendiner, *Fiske Kimball, Henri Marceau, and Carl Zigrosser of the Philadelphia Art Museum*, 1946; [5, top right] The exhibition *Modern Costumes* at the Philadelphia Museum of Art, 1948; [6, bottom] A gallery of the Museum of Living Art at New York University with Fernand Léger's painting *The City*, 1938

to the museum wasn't all about escapism—*Children of War*; *Welcome to Wings: Army Air Corps Photographs and Models*; *War Art: Paintings for "Life" Magazine*; *Our Navy in Action*; *Navy Combat Artists*; *Belgian Congo at War*; and *Advertising in War*, to name a few.

With tremendous relief, the museum reflected in June 1946, "Two dates, May 8 and September 2, 1945, will live long in our memories. The first marked the end of hostilities in Europe, the second brought the war in the Pacific to a close. With the cessation of hostilities, we began to travel the road back to rehabilitation."[8] As part of what may have been a gesture of reconciliation, Carl Zigrosser curated an exhibition of eighteenth- and nineteenth-century Japanese prints, celebrating gifts from Mrs. John D. Rockefeller and Mrs. Anne Archbold made that year. In the museum *Bulletin*, Zigrosser explained ukiyo-e and provided a formal description of the prints without a hint of politics.[9] The gifts and resulting exhibition could have been an attempt at rebuilding international relations after the devastating bombing of Hiroshima and Nagasaki that August. As John D. Rockefeller III later stated, "My own experience tells me that anyone who becomes acquainted with the arts and cultures of Asia acquires a greatly augmented sense of appreciation and respect for its peoples."[10]

Other highlights from the second half of the decade included the opening of Costume Galleries in 1947 [5] and a major retrospective of work by Henri Matisse, organized in collaboration with the artist in 1948. Georgia O'Keeffe orchestrated a gift from Alfred Stieglitz's collection that, along with the gift of the Louise and Walter Arensberg collection in 1950, further elevated the museum's status as one of the great repositories of modernism. The museum bookended the decade with Marceau's *Third Sculpture International* in 1949. [8]

By then, museum leadership had been abroad. In 1948 Fiske Kimball, Henri Marceau, Henry Clifford, Henry

[7, top] The exhibition *Two Great Mexicans: Paintings by Velasco, Prints by Posada*, at the Philadelphia Museum of Art, 1944; [8, bottom] The Philadelphia Museum of Art's third *Sculpture International*, 1949

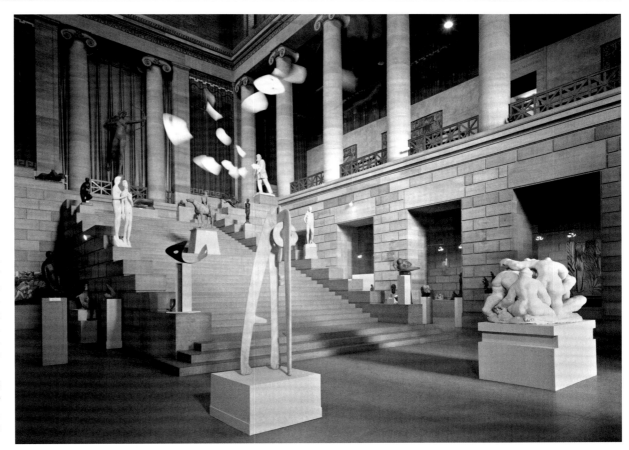

McIlhenny, and Carl Zigrosser all had traveled overseas. Kimball noted that the art collections in Europe were saved, but museum buildings did not all fare so well. "In the midst of the greatest destruction and the deepest deprivation, the life of creative art and its display in museums goes on in Europe, in a way which may well be an inspiration for us in America."[11] The Philadelphia Museum of Art was fortunate that its secure storage was not called upon to serve as a bomb shelter and that the institution was able to continue pursuing its goals over the course of the decade. Edward Warwick, as dean of the museum's school (later the University of the Arts), eloquently made the case for the essential role of art, especially in a period of war and strife, quoting Marion Lawrence: "Art is an escape to a saner, more balanced world from which one comes back fortified with keener imagination, a renewed sense of proportion and the tolerance given by historical perspective."[12]

Jessica Todd Smith is director of Curatorial Affairs and former Susan Gray Detweiler Curator of American Art, and manager, Center for American Art, at the Philadelphia Museum of Art.

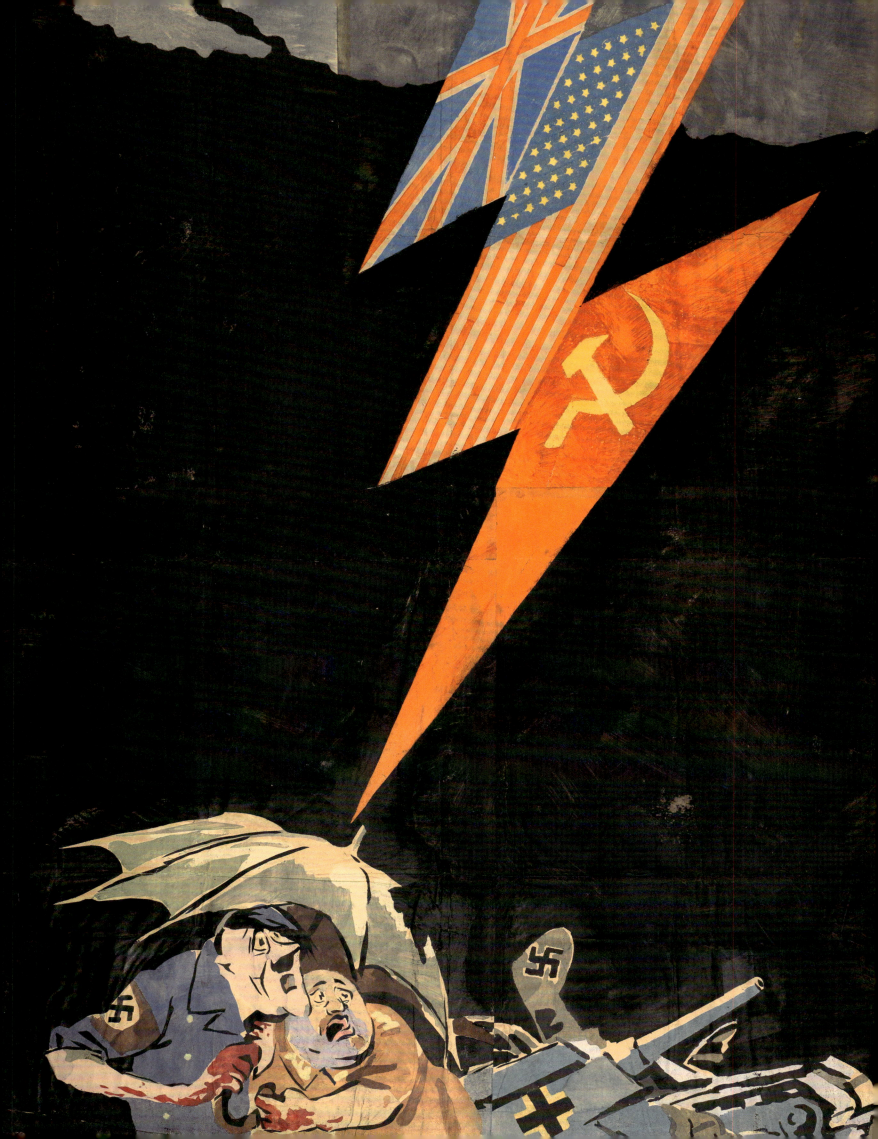

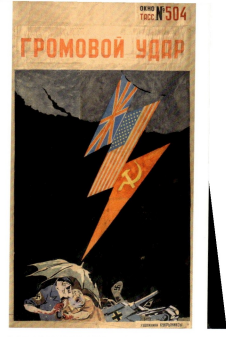

LEFT: KUKRYNIKSY (COLLECTIVE), *A THUNDEROUS BLOW*, JUNE 17, 1942; RIGHT: MARGARET BOURKE-WHITE, *AIR RAID OVER THE KREMLIN*, 1941

WITNESS TO THE WAR

Margaret Bourke-White on the Eastern Front

In May 1941 the American photographer Margaret Bourke-White arrived in Moscow with 600 pounds of photographic equipment and the conviction that Russia was poised to become the next World War II battleground, a hunch corroborated by Wilson Hicks, her picture editor at *Life* magazine.[1] For five months, Bourke-White—an intrepid photojournalist who had already crisscrossed the globe on assignment—chronicled the Russian people and unfolding events, the only foreign photographer to do so.

On June 22 Germany broke its nonaggression pact with Russia, launching surprise attacks along its border and throwing the country into war. Overnight, rationing and air-raid drills were instated and the evacuation of foreigners, except for a handful of journalists, commenced. By mid-July German forces had reached Moscow and the drills were no longer practice. When the evening siren sounded and Moscovites descended underground, Bourke-White's nightly ritual began: hiding under the bed until the air-raid warden surveilled her hotel room, then emerging to photograph the bombings. Her balcony overlooked the Kremlin and Red Square, providing sprawling views of some of Moscow's most prominent buildings—a panorama the Germans frequently targeted.

Bourke-White took *Air Raid over the Kremlin* on one of the nights of heaviest fire. At the photograph's center, Luftwaffe planes drop rows of parachute flares to illuminate the landscape below, while from the ground Soviets send fanlike bursts of tracer shells skyward to target encroaching enemy aircraft. At left, horizontal streaks of ammunition target the parachute flares and the planes that dropped them. The scattered, twinkling lights are bursting shells fired by guns around the periphery of the city, an anti-aircraft barrage intended to prevent Germany from entering Moscow's airspace.[2]

At daybreak the raid ended. Bourke-White developed films in a hotel bathtub, then slept. On waking, she headed into the city to document other aspects of the war. One of her favorite locales was the TASS Window poster studio. Established in June 1941 by the Union of Soviet Artists and headquartered at the TASS News Agency, the studio produced large-scale, stenciled posters that drew inspiration from party directives and news bulletins, but also incorporated poetry and satire.

Bourke-White described TASS as "a twenty-four-hour beehive of many of the best writers, poets, artists, and caricaturists in the country."[3] Each morning, writers translated the day's headlines into humorous verses, and by midday artists had sketches ready for production. Others worked through the night painting hundreds of stenciled reproductions. By the following morning the posters were hanging in shop windows throughout the city.

While the posters were primarily intended for a Russian audience, TASS recognized the importance of sending them abroad. After Bourke-White's visit, several were mailed to *Life*, with a shipment sent to New York's Museum of Modern Art shortly after. Many museums, including the Philadelphia Museum of Art, received TASS posters from US-based Soviet-American friends groups, to which TASS regularly shipped the latest designs.

The poster *A Thunderous Blow* was executed on June 17, 1942. The United States was by then embroiled in the war but had only recently, on June 11, signed a defensive alliance with Great Britain and the Soviet Union, commemorated by the three flags that together form a lightning bolt at the poster's center.[4] Its targets are Hitler and Mussolini, who cower together under a tattered umbrella in front of a demolished tank. Wide-eyed with fear, they cling with blood-stained hands to their only remaining shelter from the impending blow. The poster is atypical for TASS in that no verse accompanies the stencil, strengthening the visual impact of this graphic image. Its bright bolt, slicing through a dense field of black, is redolent of the parachute flares Bourke-White recorded the year before.

Bourke-White shipped negatives home as she worked, and the first images of Russia at war, including *Air Raid over the Kremlin*, appeared in the September 1, 1941, issue of *Life*.[5] Her photographs of the TASS studio were published the following month, just as the first posters were arriving in the US. Bourke-White's photographs and the TASS posters reached American audiences at a time when the country was divided over its role in the war and many distrusted the Soviet Union and its political allegiances. These images humanized Russia, recasting its citizens as patriotic, sympathetic people—worthy allies against a common enemy.

Amanda N. Bock is the Lynne and Harold Honickman Assistant Curator of Photographs at the Philadelphia Museum of Art.

THE WAR

LEGENDARY FILMMAKER KEN BURNS DISCUSSES AMERICA'S PIVOTAL ROLE IN WORLD WAR II

Alison McDonald Your 2007 film *The War* tells the story of World War II by focusing on four American towns in Alabama, California, Connecticut, and Minnesota. In this way you take the vast, harrowing tragedies of the international war and distill them to a more relatable perspective. Why did you decide to focus on the American point of view, how did you select these towns, and do you feel they help provide a more memorable lens for the audience?

Ken Burns In 1990 I made a film about the American Civil War, and that experience was so horrifying, so gory, so difficult, that I vowed never to make another film about war ever again. And while World War II was seventy-five years after the Civil War, and in many ways does not approximate it, the gore and scale of loss is similarly painful and tough.

Then, at the end of the 1990s, I learned that many graduating high school seniors thought we fought alongside the Germans against the Russians in the Second World War. Let that sink in. And thousands of veterans from World War II were dying each day, so if we were going to tell the story, we were compelled to jump in and do it while they were alive and could still share their stories. Of course, now I've made other films about war, including *The Vietnam War* and *The American Revolution*. So much for my vow.

There are probably more documentaries about World War II than any other subject, but I still felt something was missing. At first, my co-director, Lynn Novick, and I, and the production team, including Sarah Botstein, thought we could do it bottom up, focusing on the perspective of the war from one town, Waterbury, Connecticut. But there were not enough survivors from Waterbury to represent all of the soldiers' experiences across the war, both in Europe and the Pacific. That was when we decided to consider other towns of similar size, choosing Mobile, Alabama, and Sacramento, California. And we stumbled on a tiny little town in southwestern Minnesota called Luverne, mainly because of the writings of Al McIntosh, the editor of its newspaper [the *Rock County Star-Herald*].

So that brought the intimacy of small-town life in wartime together with two bustling towns, Mobile and Waterbury. Adding those towns increased the pool of available folks so we could tell the story from the bottom up as well as from the top down. We wanted it to be about experience and to be free of experts unless they also happened to have been in combat during the war.

AM In the film you mention that prior to entering World War II, the US Army was quite small—174,000 men whose uniforms included tin hats and leggings from World War I and rifles that had been designed in 1903. By the end of the war, it seems as though the entire country is working toward the war effort—for instance, car factories transform to producing warplanes, and new shipyards employ entire towns of people: "They were building planes and ships faster than they could be shot down or sunk." Strategically, the US military effort similarly started from a position of inexperience but adapted quickly to become more sophisticated. What are your thoughts on the scale and complexity of these transformations?

A private stands before a damaged altar in Acerno, Italy, on September 23, 1943.

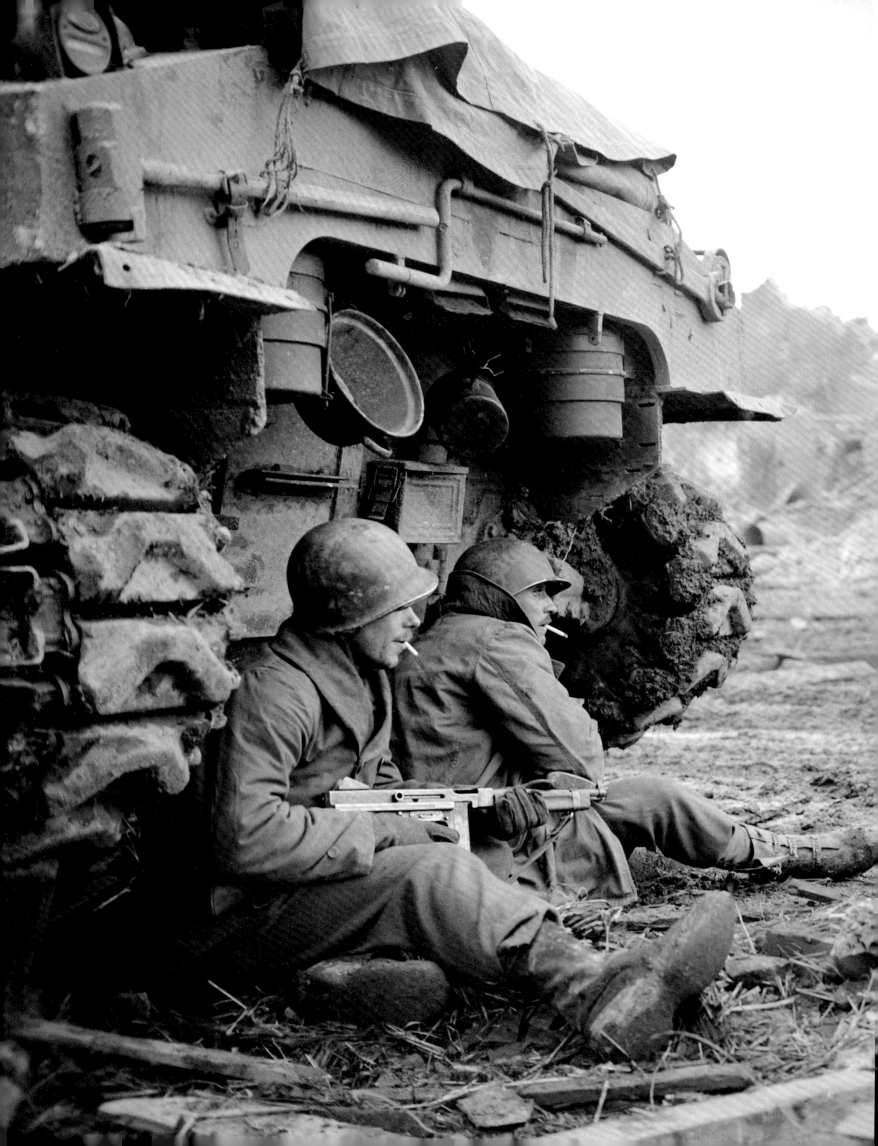

KB Well, the US comes out of the First World War highly suspicious about getting involved in any European conflicts and develops a burgeoning isolationist movement. This coincides with the 1924 Johnson-Reed Act, a restrictive immigration act limiting the number of immigrants allowed entry into the US. Before then, between 1870 and 1920, millions of immigrants entered the US. Through this act, the government is able to calculate quotas in ways that focus on allowing immigration from Protestant, northern European nations, areas Adolf Hitler would have called Aryan—less Catholic, less Jewish. And the Great Depression only intensifies suspicions surrounding outsiders. So, at the start of World War II, the US had an army smaller than that of Romania and expected soldiers to wear tin hats left over from World War I and leggings from before that. They had more horses than tanks.

But Franklin Roosevelt, the president who's helping the country get out of the Depression, understands that the United States is going to be involved in the war whether we want to or not, so he very shrewdly and manipulatively moves the US closer and closer toward preparation. And by the time the war is over, more than twelve million men and women have been in uniform for some part of it. There are enormous casualties and deaths. Every town is touched by the conflict. The amount of sacrifice Americans practiced during the Depression shows up in their ability to willingly participate in shared sacrifice, both for their country, and for their ability to survive economically.

People are planting victory gardens and participating in tin drives, they're rationing gasoline and nylon stockings, all sorts of stuff. It is the epitome of shared sacrifice, something that seems alien to our own times. And the war lifts the US out of the Depression because it's a full mobilization and it creates lots of new jobs. I also want to point out that one-quarter of all transactions were in a black market. So as much as we want to exalt in the shared sacrifice, there were a lot of people going against the grain.

After the Japanese attack on Pearl Harbor on December 7, 1941, Hitler declared war on the United States, which made Roosevelt's plan easier. It allowed him not only to fight a war against Japan, but also to fight a war against Hitler. The number one reason for the victory is American industrial production. Number two is Soviet sacrifice. And number three is American and Allied sacrifice on the much smaller Western Front. It's an extraordinary story.

AM In 1942 Japanese internment camps are set up in the US, and many Japanese Americans are moved out of and away from their homes, particularly those who were located on the West Coast. And while some German and Italian noncitizens were detained, most of those citizens retained their freedom. What was this moment like for Japanese Americans? How did they struggle differently from others, and how did they thrive despite those hardships?

KB It's racism, pure and simple. There are German and Italian nationals who are arrested and interned for some time. And they definitely suffer. But it's nothing like the 120,000 Japanese Americans, many of them second- and

Two soldiers in Geich, Germany, pause for a cigarette behind a tank on December 11, 1944.

third-generation citizens with farms and businesses, invested in their communities and in the American dream, who are uprooted and sent to internment camps in the interior. By the way, they were still drafting people out of those internment camps. It was not inconceivable to receive a death notice that basically says, "I regret to inform you that your son performed the ultimate sacrifice for his country. And oh, by the way, if you move outside this barbed wire, I have to shoot you."

AM The story of the war is so complex, so troubling, happening in so many locations at once, across years of time. Your film feels effortless for the viewer to engage with, but there must have been enormously complex puzzle pieces to layer together. From writing the overarching narration to pulling together voices across your many interviews, how do you put together a film like this? How do you take all those personal perspectives on a shared history and choose how to organize them in order to present a fairly comprehensive depiction? How do you balance chronology with dives into specific topics, mix significant historical events with intimate biographical details? How much of the narrative structure is determined in advance, and how much of the final arrangement is decided during the editing process?

KB You would think that building a film, like building a house, would be about addition, but it's actually about subtraction. I've lived in New Hampshire for forty-five years, and we make maple syrup up here. It takes forty gallons of sap to distill down to make one gallon of maple syrup. When we start a film, we collect a lot of material, and the material speaks to us. We impose on it the form of scripts. And then there's the serendipity of a particular interview with this one person we happened to meet who then says, "Have you talked to this other person?" You follow that path and then it suddenly begins to radiate out, as in Mobile, Alabama, where you discover a memoir written by a soldier you need to meet only to find out that by the time you get there he's passed away. But then you find out that his best friend is alive, and his best friend's sister is alive, and they are able to share stories that make him come alive. And suddenly you discover the writings of Al McIntosh, the journalist in Minnesota, and you get Tom Hanks to read them. And a few weeks later he says, "I'm dreaming of Al McIntosh. Is there more to read?" The first thing you hear in the film after the prologue is Tom reading an article by Al McIntosh. And the very last thing you hear at the end of the fifteen hours or so is his writing as well. He's the Greek chorus across all the films, along with Katharine Phillips, the sister of Sid Phillips from Mobile, Alabama, who's just magnificent. All of them now gone. All of them gone.

But, to answer your question, the vastness of human experience cannot be measured. So telling stories is the editing of human experience. You have to accept a certain amount of subjectivity. But if you gather as much material as you can, it begins to speak to you, and you can start to put things together; you can realize that the story doesn't work as well with this or that, and you can fit together the layers. It's incredibly complex and difficult, and why a film like *The War* takes seven years to make.

AM Cinema in the 1940s was very well attended and influential. People across the country attended movie theaters in record numbers. The newsreels that played at the start brought people together and updated the audience about our efforts in the war. They were eager to support the troops, buy war bonds, contribute to producing anything the troops might use in combat either to attack the enemy or to keep them safe. I imagine that as a filmmaker you believe in the power of storytelling. What role do you think film and propaganda played in the US during the war?

KB Well, it was really important. I could begin responding to your question by talking about the Nazi propaganda, which was done by a celebrated filmmaker, Leni Riefenstahl, who was abhorrent. Her *Triumph of the Will* and *Olympia* are great documentaries taken in and of themselves, but they're supporting a completely amoral vision of the universe.

Many great Hollywood directors sign up and make films in support of the war or about the war: Howard Hawks, John Ford, Frank Capra. Movie stars are enlisting and serving in the military, but people are also participating in bond drives and things like that. And so you have a relatively homogeneous population that is getting its media from only a few sources, unlike today when the media is so completely fragmented that each person is sort of their own content receiver and therefore susceptible to all forms of malevolent stuff. In those days, people read newspapers, listened to the radio, and went to the cinema where they saw newsreels.

There were billboards and drives locally, statewide, and nationally. There were bonds to buy, things to do, sacrifices to make. And Americans did it in an extraordinary way. And while industrial might is what permitted it to happen, it was the American workforce's eagerness to pitch in and the American people's willingness to participate in battles that led to victory. There's absolutely no reason why some farm kid from Nebraska should enlist. He's not getting paid a lot of money to be in the military and go into the battlefield. He's not there for empire or for conquest or for loot. He's there for an abstract idea. But they did go, and they did fight. And the footage that was taken by very brave cameramen looking back at Omaha Beach and watching four or five Americans drop into the water at a time was testament to that. It was one of the greatest sacrifices ever made. And a lot of it wouldn't have happened unless everybody was aware that they were in the same boat pulling in the same direction. That comes from propaganda. It comes from the media telling people back home what's happening.

AM How did you develop the soundtrack for this film? Did you collaborate with Wynton Marsalis?

KB Well, that time period has some of the greatest music of all time. You have the Great American Songbook, which is at its height during this moment. There's classical music that is, of course, kind of universal to human circumstance as opposed to the way pop music is specific to a particular time and place. But yes, I asked Wynton Marsalis if he would score it, if he would do a theme for each of the four towns, if he could give us a variety of other sounds or themes that had to do with battle or the absence of battle, triumph, and tragedy. And he did. So the film is a wonderful amalgam of sounds. It's interesting that you brought that up, because I listen to this soundtrack more than that of any other film I've done. Sometimes it's the classical stuff, or it might be Elgar's. We know Edward Elgar for "Pomp and Circumstance," but his *Enigma Variations*, particularly the one that we use the most, "Nimrod," is one of the most beautiful pieces of music. It starts quiet and builds and builds, and then it lets go. If you're not in tears . . . And Vivaldi and Mendelssohn, just some amazing, amazing classical composers in addition to the jazz and pop tunes of the time, all of which are equally important and are supported by Wynton's extraordinary themes.

AM As a filmmaker, you must realize that you're preserving stories that might otherwise be lost, but there are so many stories and voices to decide between. Why is it important to preserve the stories of the past, and why with this moment in particular?

KB I'm a filmmaker. My job is to tell stories. But when the film is done, it belongs to the audience. When it's done, it's yours. How you see it is important. And the response to *The War* has been staggering and still continues to this day. And that's heartening.

In a big documentary series like *The War*, there are a million problems to solve, but I don't see "problems" as pejorative, I just see them as a kind of friction to overcome. That's the work that I like; it is a challenge, but when it's done, it's done. And what's so satisfying is that our audience covers a spectrum of political beliefs and regional areas—just look at the diversity of the towns that gave most Americans some stake in the story. They're close to Sacramento or Luverne, or to Mobile or Waterbury. When we first screened the film, emotions were running high, and many people were upset by the enormous tragedy of it all. And I will never forget what an associate said to me. He said, "You know, there are no ordinary lives." Every life has its own remarkable story to discover. When you feel you have honored that, you release the film.

Ken Burns has been making documentary films for almost fifty years. directing and producing some of the most acclaimed historical documentaries ever made.

Alison McDonald is the Chief Creative Officer at Gagosian and has overseen marketing and publications at the gallery since 2002.

US soldiers mount the American flag outside a second-story window in Bitche, France, on March 16, 1945.

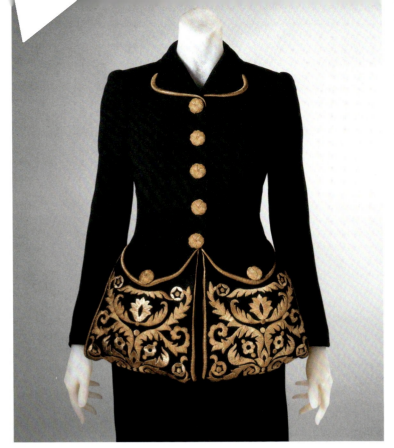

ELSA SCHIAPARELLI, WOMAN'S DINNER JACKET, SPRING 1940

ELSA SCHIAPARELLI, WOMAN'S DINNER JACKET, SUMMER 1941

"NEEDLES AND GUNS"

Elsa Schiaparelli and America

France and Great Britain's declaration of war on Germany on September 3, 1939, had an immediate effect on French fashion. Male workers in the industry, including the heads of several couture houses, were mobilized, and the production of many materials, such as silk, were delegated to the war effort. Couturière Elsa Schiaparelli, who had a large American following—from trade buyers to private clients—and was widely covered by the fashion press, cut her workforce from 600 to 150. Her remaining staff agreed to reduced wages and worked every other week so more could remain employed.

Schiaparelli's spring 1940 collection, shown in October 1939, featured only thirty models worn by three mannequins and was completed in less than three weeks. She recalled that it was shown as "a matter of prestige, to prove to oneself that one was still at work."[1] The fashion correspondent Kathleen Cannell noted that the first wartime midseason collections forecast a complete change in world fashion: "Couturiers have buckled down and created clothes, not sensational stunt styles. . . . Each wartime fashion opening has assumed the character of a patriotic gesture, with all that is left behind the lines of 'tout Paris' turning out in force to make it a success." She declared Schiaparelli's collection "inspired," commenting that it "took us back to the good old days when she made only sport clothes and a few evening gowns and every model was a 'chef d'oeuvre.'"[2]

Schiaparelli's military-themed collection included a black rayon dinner jacket embroidered in gold. Its oversize "cash and carry" pockets were designed to take the place of a handbag, an accessory that would have been too hard to carry if one was already burdened with a gas mask. In early December she flew to New York for a two-week visit in connection with her perfume business, taking with her a mostly black travel wardrobe drawn from the October collection. This jacket with "cash and carry" pockets, and another in velvet, could be combined with any one of four day or four evening dresses. Splashes of color were added with a Trench Brown wool suit, a Maginot Line Blue corduroy sport dress, Legion Red spats, and a Fusée pink turban. According to *Vogue*, Schiaparelli's wardrobe, packed in four frameless, zipper-closed bags, spoke to "limited luggage, unlimited chic."[3]

On June 14, 1940, German troops entered Paris, and for the next four years the city was under the control of the Vichy government. Schiaparelli and several other couturiers fled to Biarritz with a small number of staff at the beginning of the German occupation.[4] A month later she flew to New York for a previously planned cross-country lecture tour to more than thirty cities, speaking on "Clothes and the Woman." She planned to illustrate her lecture with a specially designed wardrobe labeled "Authorized Schiaparelli Reproduction—Special Collection 1940" that she had arranged to be copied by American manufacturers and sold at select stores. Shipped ahead of time, the collection was sunk en route by the Germans. To provide a replacement, Bonwit Teller department store offered its workrooms for the copying of her personal wardrobe, which was then reproduced for sale.

Schiaparelli returned to Paris on January 21, 1941, and the following month presented her collection for summer 1941. One of its highlights was a dinner ensemble offering a subtle commentary on women's roles in Vichy France. The brightly colored velvet jacket, worn with a long black dinner dress and faux apron, was modeled on an eighteenth-century man's waistcoat. Embroidered three-dimensional vegetables and fruit formed the buttons, and scattered motifs included turnips and artichokes, which before the war were considered cattle feed and inedible but now were seen as fit for human consumption. In May, Schiaparelli returned to New York, where she would remain for the duration of the war. In 1945 she returned to Paris to present her first postwar collection.

Dilys Blum is the Jack M. and Annette Y. Friedland Senior Curator of Costume and Textiles at the Philadelphia Museum of Art.

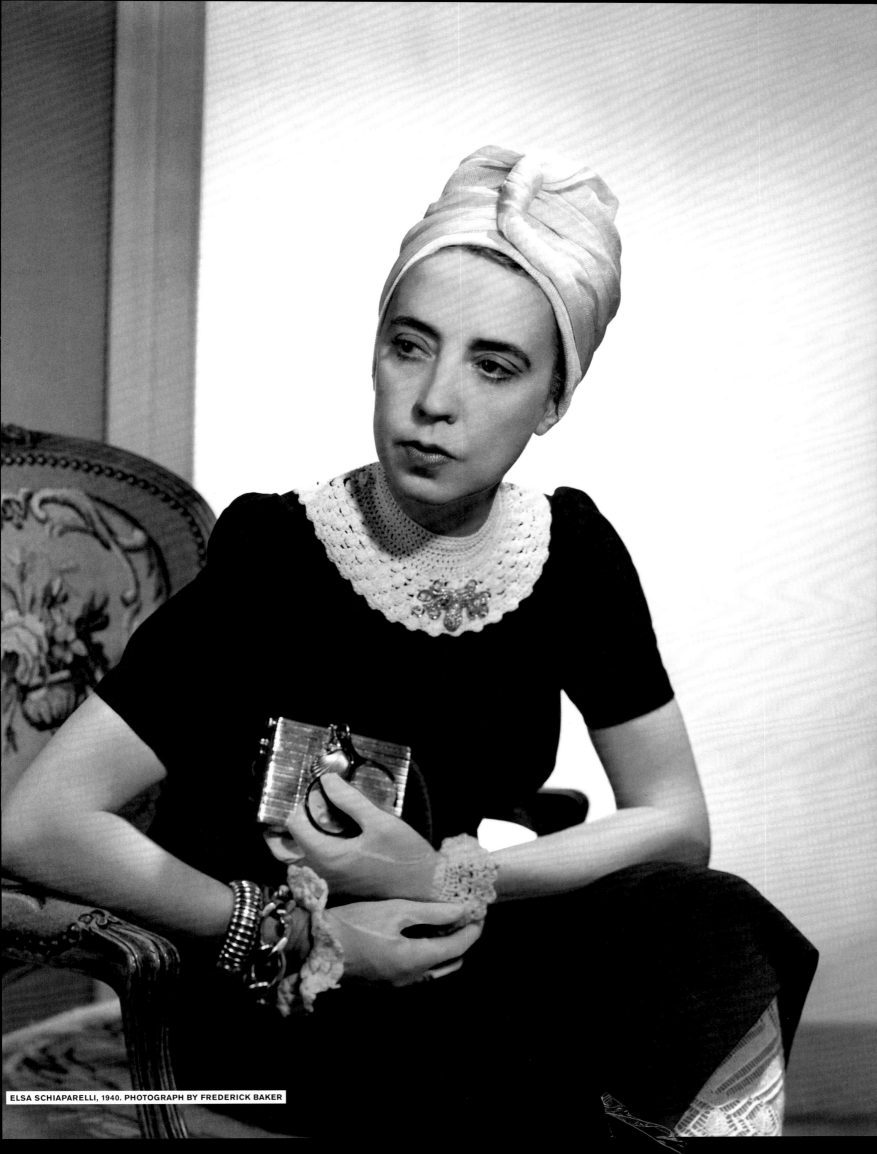
ELSA SCHIAPARELLI, 1940. PHOTOGRAPH BY FREDERICK BAKER

THE SOVIET POET'S VERSE TESTIFIES TO THE DEPTH OF SUFFERING EXPERIENCED BY HER GENERATION AND THE ENDURING POWER OF THE HUMAN SPIRIT.

THE POEMS OF ANNA AKHMATOVA

Anna Akhmatova was the pen name of the Soviet poet Anna Gorenko, derived from the surname of her maternal great-grandmother.[1] She was born in 1889 near Odessa, in modern-day Ukraine, raised in Tsarskoye Selo, near Saint Petersburg, and began publishing by 1911. She found fame early on as a darling of the pre-revolutionary Russian literary scene, and that notoriety would follow her throughout her life—at times making it more difficult for her to navigate politically charged situations. During her lifetime Akhmatova witnessed the Russian Revolution, World War I, the rise of the Soviet Union, the Stalinist terror, and World War II. All these events directly affected her, but the pain caused by the Stalinist regime had the gravest impact. Her first husband, Nikolay Gumilyov, was executed in August 1921 for suspected participation in a counterrevolutionary plot. She only learned of his death the following month in a newspaper. Her son, Lev, was arrested several times in the 1930s and 1940s, and spent much of the period between 1935 and 1956 imprisoned in Siberian forced-work camps. In 1941 he was released early from his imprisonment to serve in the Red Army, though he was arrested and sent to work camps several more times. Many of her friends, including Osip Mandelstam and Akhmatova's lover Nikolay Punin, who perished in a Siberian work camp, were frequently arrested and persecuted by the Stalinist regime.

These major inflection points are reflected in the more than eight hundred poems that make up her work. Akhmatova details with often heartbreaking precision the myriad struggles of daily life in the Soviet Union at this time: she mourns the loss of friends killed by the brutality of Stalinism, laments the destruction of World War II, and fears for the lives of the soldiers of the Red Army. The agony of experiences felt by countless people across the Soviet Union were memorialized in her poem cycle *Requiem*, perhaps her most renowned work. Despite the overwhelming hopelessness and devastation that Akhmatova must have felt during her life, her poems all emanate her characteristic laconic linguistic restraint. During the Soviet Union's participation in World War II, Akhmatova was forced to evacuate Leningrad and live in Tashkent, a city in modern-day Uzbekistan. Before leaving Leningrad, she called upon the city's women in a radio address to remain brave during the difficult days ahead, becoming a symbol of suffering and a source of inspiration for others during the war.

Akhmatova frequently came up against the cultural censors of the Soviet Union. In 1946 she was expelled from the Union of Soviet Writers by one of Stalin's officers, who claimed that her writings were immoral and ideologically harmful, especially to the minds of Soviet youth. This act devastated Akhmatova and left her with virtually no income; her earlier published works—the majority of her literary output—were banned and burned. Her situation after the expulsion was so dire that she sought mercy by writing patriotic poems in praise of Stalin and his regime in an effort to gain leniency.

Akhmatova devised creative ways to escape some of the scrutiny of the cultural watchdogs of the day. Some of her work, most notably the poems of *Requiem*, survived for many years outside of any written form. Instead, ten trusted members of Akhmatova's inner circle memorized the lines of the poems and destroyed the original manuscripts. *Requiem* circulated in this underground manner for years before its first publication in Munich in 1963, and it was not published in the Soviet Union until 1987.

Outside the Soviet Union, Akhmatova's popularity increased with every passing year, as seen in her 1965 and 1966 nominations for the Nobel Prize in Literature. Steadfastly loyal to her country, she remained in the Soviet Union until her death in 1966.

Isabella Szyfer is an award-winning poet and scholar currently based in New York. She focuses primarily on medieval literature in Columbia University's Department of English and Comparative Literature, specializing in Old English and Old French verse.

SELECTED POEMS

Each of these poems offers a unique perspective on the realities of life in the Soviet Union in the 1940s. The details in the poems, such as waiting in lines of thousands to hear news of an imprisoned family member or learning of the capture of Paris by the Germans, are echoes of the moments that defined lives under the Stalinist regime and during the onslaught of World War II. Akhmatova fears as a mother, examines destruction as a scholar, and loves as a patriot. These poems exemplify, in a single artist's canon, the multifaceted nature of life in the Soviet Union during this time—the joy, the despair, the fear, the hope—in a way that is completely unique.

IN THE FORTIETH YEAR

BEGINNING OF THE WAR

In August 1939 the Soviet Union signed a nonaggression pact with Nazi Germany. After the German invasion of western Poland in early September 1939, the Soviets invaded eastern Poland as well. But once the Nazis attacked the Soviet Union in June 1941, the Soviet Union formally joined the Allied Powers. Akhmatova was deeply affected by the Siege of Leningrad, which began in late 1941 and forced her to evacuate to Tashkent. Prior to her evacuation, however, Akhmatova knew of the capture of other European cities by the Germans, most notably Paris, which made a large impression on her, as she had spent time there earlier in her life. The destruction tinges the poems from this time, particularly *In the Fortieth Year,* Akhmatova's odes to Paris and London in the wake of the capture of the former and the destruction of the latter during the Blitz.

In the Fortieth Year was not published until 1946, when it was condemned by the Soviet government, and the journal that published it was suppressed. In this work, Akhmatova paints Paris with an air of funereal silence and characterizes the Blitz of London as a new Shakespearean tragedy too horrible to be read.

1

When they come to bury the epoch,
Not with psalms will they mourn it,
But with nettles, with thistles,
They will have to adorn it.
And only the gravediggers jauntily
Work. Business won't wait!
And quietly, oh God, so quietly
That it is audible, is how time passes.
And afterwards it floats away
Like a corpse on a thawing river—
But the son won't recognize his mother,
And the grandson will turn away in anguish.
And heads will bow even lower
And the moon move like a pendulum.

And so it is—over ruined Paris
There is now such a silence.

August 5, 1940

2

To the Londoners

Time, with an impassive hand, is writing
The twenty-fourth drama of Shakespeare.
We, the celebrants at this terrible feast,
Would rather read *Hamlet, Caesar* or *Lear*
There by the leaden river;
We would rather, today, with torches and singing,
Be bearing the dove Juliet to her grave,
Would rather peer in at Macbeth's windows,
Trembling with the hired assassin—
Only not this, not this, not this,
This we don't have the strength to read!

1940

LIFE UNDER STALIN

One of Akhmatova's most famous works, *Requiem* is a cycle of poems that render the anguish of life under the Stalinist regime in horrifying detail. The poems center on the imprisonment of millions of Russians, including Akhmatova's son, Lev Gumilyov, and several of her friends, in the Siberian work camps. Though the cycle was written in the early 1940s, it was not published until 1963, instead being transmitted orally by close friends who had memorized the lines. At the beginning of *Requiem*, in "Instead of a Preface," Akhmatova recounts the practice of standing in "prison lines" for hours to pass on food deliveries for imprisoned relatives, plead on their behalf, and learn news of them. It is here that she reveals the impetus for the poem's composition: an exchange with another woman, who, lips blue from the cold of waiting in line for news of her loved one, recognizes Akhmatova and asks her to describe the "terrible years of the Yezhov terror." In "Dedication," Akhmatova grieves for imprisoned friends as if they were already dead—an indication of the brutality of life in the work camps. In "VIII: To Death," she references the blue caps of the NKVD, the Soviet secret police who were responsible for many of the imprisonments. She also mentions the Yenisey River in Siberia, along which many of the camps were located.

REQUIEM

Instead of a Preface

In the terrible years of the Yezhov terror, I spent seventeen months in the prison lines of Leningrad. Once, someone "recognized" me. Then a woman with bluish lips standing behind me, who, of course, had never heard me called by name before, woke up from the stupor to which everyone had succumbed and whispered in my ear (everyone spoke in whispers there):
 "Can you describe this?"
 And I answered: "Yes, I can."
 Then something that looked like a smile passed over what had once been her face.

April 1, 1957
Leningrad

Dedication

Mountains bow down to this grief,
Mighty rivers cease to flow,
But the prison gates hold firm,
And behind them are the "prisoners' burrows"
And mortal woe.
For someone a fresh breeze blows,
For someone the sunset luxuriates—
We wouldn't know, we are those who everywhere
Hear only the rasp of the hateful key
And the soldiers' heavy tread.
We rose as if for an early service,
Trudged through the savaged capital
And met there, more lifeless than the dead;
The sun is lower and the Neva mistier,
But hope keeps singing from afar.
The verdict . . . And her tears gush forth,
Already she is cut off from the rest,
As if they painfully wrenched life from her heart,
As if they brutally knocked her flat,
But she goes on . . . Staggering . . . Alone . . .
Where now are my chance friends
Of those two diabolical years?
What do they imagine is in Siberia's storms,
What appears to them dimly in the circle of the moon?
I am sending my farewell greeting to them.

March 1940

VIII

To Death

You will come in any case—so why not now?
I am waiting for you—I can't stand much more.
I've put out the light and opened the door
For you, so simple and miraculous.
So come in any form you please,
Burst in as a gas shell
Or, like a gangster, steal in with a length of pipe,
Or poison me with typhus fumes.
Or be that fairy tale you've dreamed up,
So sickeningly familiar to everyone—
In which I glimpse the top of a pale blue cap
And the house attendant white with fear.
Now it doesn't matter anymore. The Yenisey swirls,
The North Star shines.
And the final horror dims
The blue luster of beloved eyes.

August 19, 1939
Fountain House (Saint Petersburg)

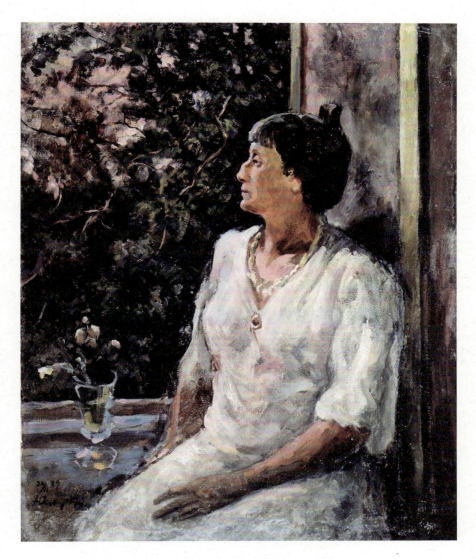

Aleksandr Aleksandrovich Osmyorkin
Portrait of Anna Akhmatova, c. 1939

IMPRISONED IN SIBERIA

Akhmatova wrote "Cleopatra" while her son, Lev Gumilyov, was imprisoned in a Siberian labor camp. The poem's epigraph comes from a poem by the Russian poet and playwright Alexander Pushkin also titled "Cleopatra." Pushkin was one of Akhmatova's greatest influences and is referenced several times in her work. After the Roman emperor Augustus seized Egypt, he intended to take Cleopatra and her children to Rome as prisoners in his triumphal procession. Akhmatova situates herself here as Cleopatra before her suicide, attempting to remain queenly and continuing to attend to her children while their humiliation and destruction loom on the horizon.

CLEOPATRA

Alexandria's palaces
Were covered with sweet shade
Pushkin

She had already kissed Antony's dead lips,
And on her knees before Augustus had poured
 out her tears . . .
And the servants betrayed her. Victorious
 trumpets blare
Under the Roman eagle, and the mist of evening
 drifts.
Then enters the last captive of her beauty,
Tall and grave, and he whispers in embarrassment:
"You—like a slave . . . will be led before him in the
 triumph . . ."
But the swan's neck remains peacefully inclined.

And tomorrow they'll put the children in chains.
 Oh, how little remains
For her to do on earth—joke a little with this boy
And, as if in a valedictory gesture of compassion,
Place the black viper on her dusky breast with an
 indifferent hand.

February 7, 1940

END OF THE WAR

Akhmatova's poems from late in the war, "Untitled (De profundis . . .)" and "Lamentation" (both 1944), survey the damage wrought by the conflict. *De profundis*, Latin for "from the depths," is the beginning of the Roman Catholic prayer for the dead. Akhmatova mourns not only the war dead, but her generation, which had seen two world wars and their devastation. "Lamentation," written upon Akhmatova's return to Leningrad, sees the poet mourning her ravaged home city after its protracted siege by the Nazis. Also present in work from this time, seen best in "From the Airplane," is Akhmatova's joy at returning from her wartime evacuation in eastern Russia. This poem cycle takes its name from Akhmatova's May 1944 flight from Tashkent to Moscow and testifies to her patriotism and hope for her country.

Untitled (De profundis . . .)

De profundis . . . My generation
Tasted little honey. And now
Only the wind hums in the distance,
Only memory sings about the dead.
Our work was not finished,
Our hours were numbered,
Till of that long-awaited watershed,
Till of that great mountain's peak,
Till of that violent flowering
Remained only one breath . . .
Two wars, my generation,
Lit your terrible path.

March 23, 1944
Tashkent

Lamentation

I won't throw up my hands
At the anguish of Leningrad,
I won't wash it with tears,
I won't bury it in the ground.
I'll go a mile beyond
The anguish of Leningrad.
And not with a glance, not with an allusion,
Not with a reproach, not with a word,
 But with a bow down to the ground
 In a green field
 Will I pray.

1944
Leningrad

From the Airplane

1

For hundreds of versts, for hundreds of miles,
For hundreds of kilometers,
Salt beds lay, feather grass rustled,
Cedar groves darkened the way.
As if for the first time, I
Looked at her, the Motherland.
I knew: all this is mine—
My soul and my body.

2

With a white stone I'll record this day
When I sang of victory,
When I met with victory,
When I flew, outstripping the sun.

3

It's spring at the airdrome,
The grass rustles underfoot.
Home, home—I am really home!
How new everything is, and how familiar,
And in my heart such languor,
My head spins with delight . . .
With a crisp clap of May thunder—
Here is Moscow, the conqueror!

May 1944

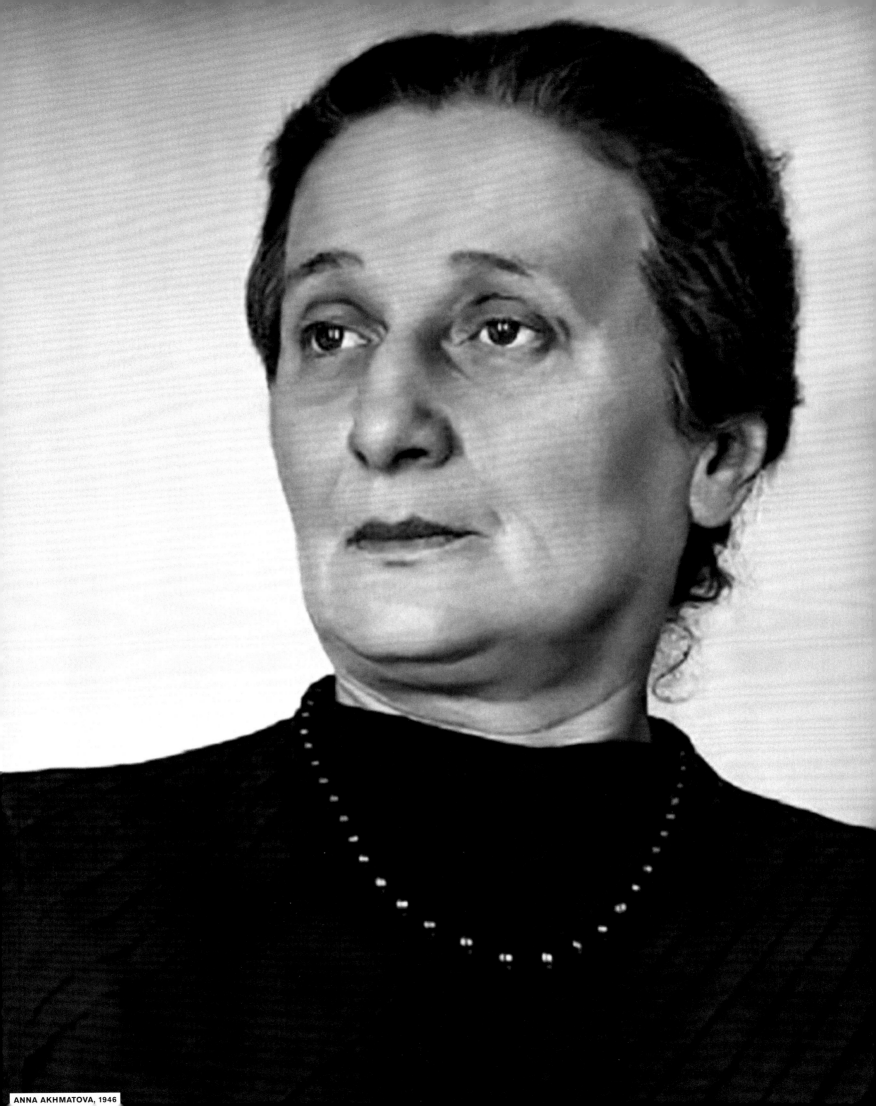
ANNA AKHMATOVA, 1946

UNSEEABLE THINGS

War, Technology, Photography

There is something about darkness that is a guardian to man's unconscious.
—Weegee[1]

A concessions salesman, body heavy with slumber, lists across the center of Weegee's photograph. He is seated uncomfortably—one hand stuffed clumsily into a coat pocket, the other propping up his head—but appears too fatigued to care. The child in the foreground gazes straight ahead, seemingly unconcerned with the man nodding off behind her. She has a peculiar quality: her skin eerily milky and translucent, her stare vacant with pupil dilated, her features simultaneously in and out of focus. A jet-black void envelops both figures, masking their environs and relationship in space.

Weegee made this photograph during a circus performance using infrared film and flash in the arena seats of New York's Madison Square Garden. Infrared, which records light outside the human visual spectrum, was not a new technology but became widely available commercially shortly before the onset of World War II.[2] Unlike the commonly used magnesium flash, which emits a blinding burst of light, infrared bulbs give off only a faint red glow, making this technology an indispensable tool of photojournalists working under air-raid blackout conditions. Weegee made his first infrared photographs in 1942 during an air-raid drill, but soon gravitated to venues like circuses and motion picture houses.[3]

WEEGEE, *TIRED BUSINESSMAN AT THE CIRCUS*, 1943; OPPOSITE: HAROLD EDGERTON, *ATOMIC BOMB EXPLOSION*, c. 1946–52

Already famous for his sensationalist nighttime photographs of New York's underbelly, Weegee was well accustomed to making pictures in the dark. But with infrared he could work surreptitiously with what he called "invisible light," taking his camera into darkened venues (often disguised as an ice cream man) to capture people unaware.[4]

Harold Edgerton also experimented with flash technology, but for an entirely different purpose. A professor of electrical engineering at MIT and a pioneer of stroboscopic stop-motion photography, Edgerton pivoted during the war to create a flash system capable of nighttime reconnaissance aerial photography. By 1946 he was contracted by the Atomic Energy Commission (AEC) to document atomic bomb tests. The intensity of light emitted during these explosions required Edgerton to invent the Rapatronic (short for Rapid Action Electronic) camera, which had a shutter system that could open and close at speeds up to one-millionth of a second. At each test site, he positioned the Rapatronic about seven miles from the blast, attached it to an eight-inch Newtonian telescope, and set it to capture images at timed intervals.[5]

Many of Edgerton's photographs for the AEC remain classified, but *Atomic Bomb Explosion* was published as early as 1960 and has been widely circulated.[6] It depicts one of the first microseconds of the explosion just before the formation of the more readily recognizable mushroom cloud. Edgerton's photograph reveals the fireball's devastation even in this nascent moment as it vaporizes the steel tower from which it was just launched. While the photograph was taken during the day, Edgerton made the troubling discovery that the point of explosion brought total darkness, enshrouding the otherwise sundrenched Nevada desert in a black haze. This photograph chronicles a moment so fleeting as to be impossible to perceive with the naked eye, presenting us with an unfamiliar and otherworldly form that evades precise description.

Photographic technologies like infrared and Rapatronic pictures wrested from darkness the unseeable, unknowable things around us, satisfying people's curiosity about what we look like when we aren't trying to look any particular way and what happens in the microseconds after atomic nuclei split. Weegee's seemingly innocuous photographs of circus-goers and Edgerton's images of atomic explosions reveal in equal measure our vulnerability and our destructiveness. Both foretell the anxieties about mass surveillance and mass violence that took hold of Americans in the 1940s and persist into the present.

Amanda N. Bock is the Lynne and Harold Honickman Assistant Curator of Photographs at the Philadelphia Museum of Art.

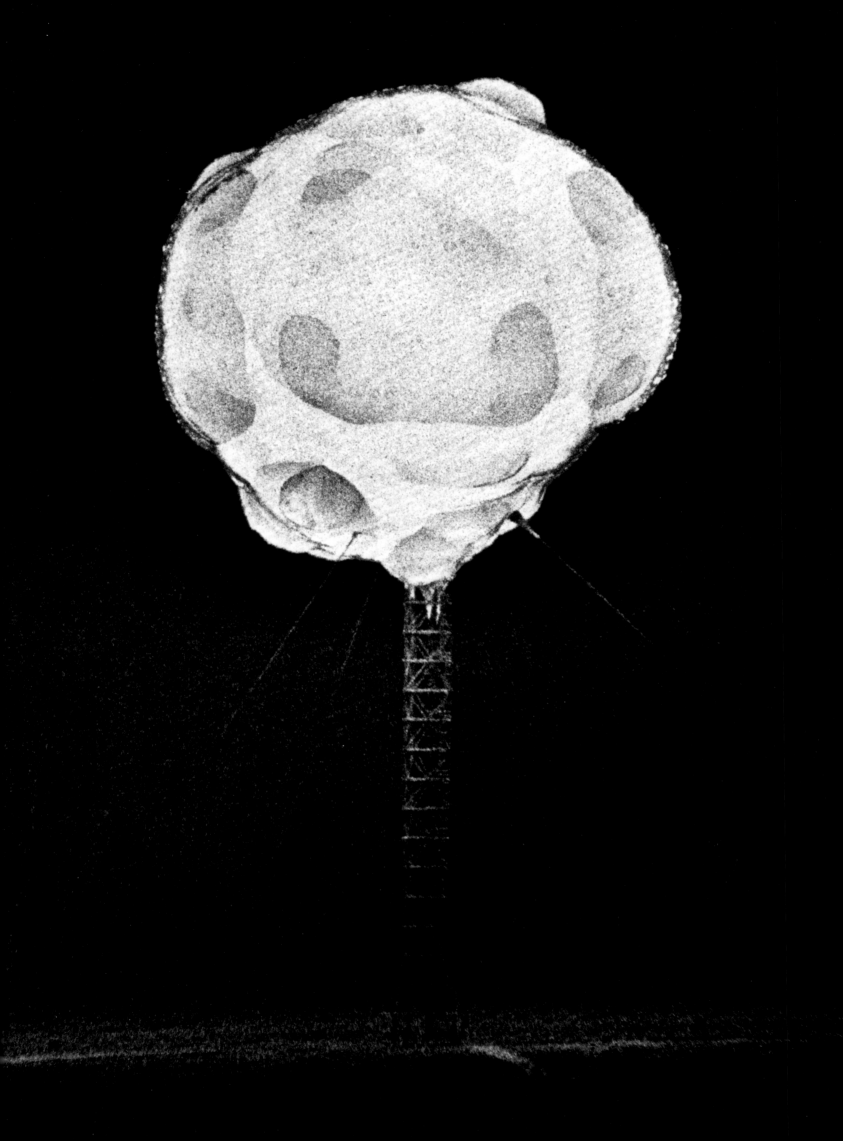

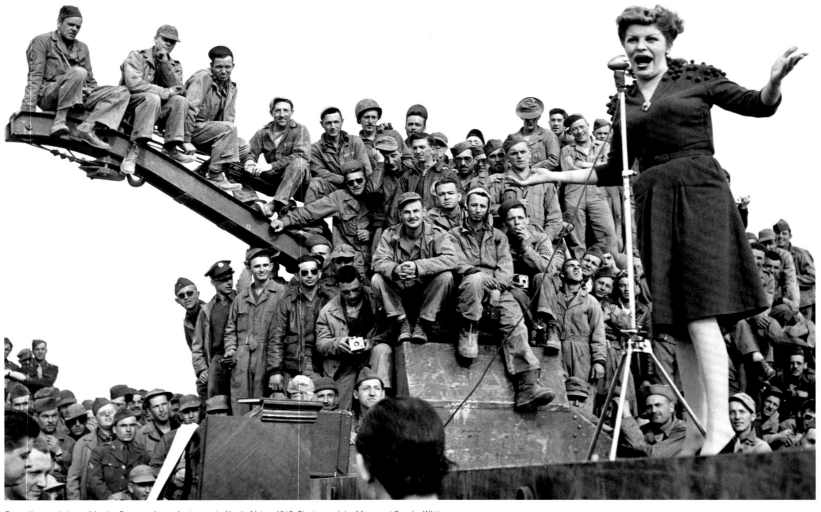

Comedian and singer Martha Raye performs for troops in North Africa, 1943. Photograph by Margaret Bourke-White

CULTURAL RENEGADES

CHRISTIAN McBRIDE DISCUSSES INNOVATIONS IN MUSIC OF THE 1940s

Philadelphia-born bassist and Grammy Award–winning jazz powerhouse Christian McBride speaks with Alison McDonald about how musical genres from the 1940s helped shape the sounds of today, the vital role musicians played at this moment in history, and how music can participate in social change.

ALISON McDONALD This project is focused on the 1940s, a decade that witnessed some of the darkest moments in human history, but also some of the most innovative. Generally speaking, when you think about this moment in history what resonates most for you?
CHRISTIAN McBRIDE The first thing that comes to mind about the '40s is World War II and how that shaped an entire generation of thinking, of social construct, of music, of innovation, the breaking down of racial barriers—not a lot but some—and how that set the stage for the '50s, which a lot of people consider an era of victory. People were happy. Americans were flourishing. Families were burgeoning all over the country despite the Korean War going on in the background. That was all set up by World War II.

The first generation of beatnik poets also happened around this time. People like Jack Kerouac and Allen Ginsberg soon followed, after the bebop revolution. So a lot of interesting things happened in the 1940s.

AM There are many great genres of music that were popular during this decade: blues, gospel, big band, jazz, bebop, bluegrass, swing, Latin, country. If you were to curate a selection of music to reflect that time, what would you be sure to include and why? Are there any artists, groups, types of music, or events that resonate with you from this era?
CM There was the infamous musicians' strike that started in 1942—well, it's famous to musicians at least—during which artists did not record any new albums for two years. There weren't any records made during that time, which is an interesting fact that not a lot of people discuss. But in terms of innovation, particularly on the music side, it was the era of bebop. It was when Charlie Parker and Dizzy Gillespie and Thelonious Monk and Bud Powell, Ray Brown, Charles Mingus, Max Roach, Roy Haynes, Kenny Clark, and Django Reinhardt turned American music upside down.

This new thing called bebop just spun people's heads around. And bebop musicians became the cultural renegades of the '40s. If you wanted to be hip, if you wanted to be down, you had to listen to bebop.
AM What are your thoughts on where jazz was at the beginning of the 1940s? How had it developed and evolved toward the end of the decade?

CM The beginning of the '40s was still the big band era. Just before the war started, it was an era when people were going to ballrooms. And they were dancing to the Count Basie Orchestra, which actually had just started, as it was founded in the mid-1930s. So in the early '40s, the Basie band ruled the world. Duke Ellington was king.

Benny Goodman's band was huge in the late 1930s. Earl "Fatha" Hines. And Charlie Parker, who was playing with Jay McShann, Dizzy Gillespie, who was playing with Cab Calloway. Something started to happen during the war. And it was because of the economy with the country at war. A lot of bands got decimated. A lot of musicians actually had to go to battle. And a lot of clubs—around the country but particularly in New York—didn't have money to pay for big bands anymore. So the big band era slowly started to fade away during the war years. But out of the ashes rose this new music that Charlie Parker and Dizzy Gillespie created called bebop.

And so, in just a few short years, the big band era was a bygone era. The big bands that still existed were sort of new school, like Dizzy Gillespie's. Even Billy Eckstine's band was starting to wind down a little bit by the end of the '40s.

By the 1950s Count Basie had to travel with just an eight-piece band—previously there had been as many

American Federation of Musicians members on the streets of New York, c. 1947

as eighteen musicians. Duke Ellington lost Johnny Hodges because Hodges wanted to start his own band, though he wound up going back to Duke at some point.

Lots of stuff happened in the music world—well, particularly in jazz. One of the big bands that was doing well in the '40s was the International Sweethearts of Rhythm, America's first acknowledged all-female big band. A lot of great musicians came through that band. But even it was gone by the 1950s. You couldn't sustain a big band anymore, kind of like now. [*Laughs*]

AM The United Service Organizations (USO) was founded in 1941 in response to the war efforts, as a way to bring live entertainment to the troops. By 1947 there had been 400,000 performances. Music was a way for the troops to feel connected to their loved ones and to rally support across the United States for the war effort. Though we are in a very different historical moment, I wonder what ways you see music unifying people today?

CM I believe most people would agree that artists, particularly musicians, could be the world's greatest ambassadors because we always bring a message of peace. We don't bring a message of static, or of aggressive disagreement. We are messengers of peace and love. To get people to listen to you, you want them to feel like there's a peaceful atmosphere.

And I feel like the State Department used to do that for many, many years. They would send people like Duke Ellington and Benny Goodman and the great Louis Armstrong over to places like Eastern Europe and Russia and Central and South America as peace offerings to those countries. And that's why they were hailed as heroes. And that's why America was able to be respected on a much higher level, particularly from an artistic point of view, because we had people like Duke and Pops and Benny Goodman and all these great musicians.

By the 1960s, there were a few artists who realized that as wonderful as it was that the USO was sending a lot of artists to war areas to perform, there really was only one type of entertainment they were sending, and it was typically performers who were right down the middle of mainstream pop. At that time that meant people like Bob Hope, Milton Berle, Frank Sinatra—and by the Vietnam War a lot of African American soldiers started to complain and request that Black artists come there to perform. There is a popular story about when James Brown spent his own money to fly to Vietnam because he wanted to perform for the troops and because they demanded it. And once James Brown went things started changing. Then Sammy Davis Jr. started going, and the types of musicians the USO was sending became much more diverse. But to answer your question of how musicians and music affect the world, music is the only analgesic that can fix the world.

AM Music at that moment was highlighting the struggle for freedom abroad while discrimination and segregation were happening to Black servicemen. John Coltrane joined a swing band in the navy but had to be listed as a guest performer because it was an all-white band. Dave Brubeck started a group called the Wolf Pack while he was in the army, one of the first mixed-race bands in the military. How do you think music can enact social change?

CM It's been happening all along. That happened even before the 1940s, when Duke Ellington helped to integrate the Cotton Club. It happened when Benny Goodman hired Teddy Wilson and Lionel Hampton to join his band in the mid-'30s. And oftentimes I feel like you have to meet those discriminatory practices—and at that time, open segregation—you had to meet it head on, because if someone says to you, "No Blacks allowed, no women allowed, no Asians allowed, no gays allowed," I think there is a wonderful way that artists can fix that through music.

I don't think anyone is going to tell Benny Goodman he can't play in their city once they hear Teddy Wilson and Lionel Hampton. But Benny Goodman, of course, could have said, "Guys, look, I'm going to have to fire you because you're not allowed to play in this town." But no one with any dignity would ever do that. So I think that's the beautiful thing music can do. Musicians can do very big things with very simple things.

AM In France during these years there were Black creatives and intellectuals, including American musicians, who noted feeling more respected there. Considering the regimes waging war across Europe, that's interesting to consider. After the war, in 1949, Miles Davis went to France and said it changed the way he looked at things because he appreciated the way he was treated. In the previous decades Josephine Baker was similarly embraced by Paris audiences. What do you think were some major differences between the US and France for performers at this moment?

CM At that time in the 1940s, jazz was not taken seriously. Jazz was just considered party music. It was not considered high artistic content. It was viewed as something that people went and partied and danced to. And they would use words like "fornicate," or talk about lust-like behavior, similar to what's said about hip-hop today. And that's how most people viewed jazz during that time. Now, you can't listen to Charlie Parker and Dizzy Gillespie and tell me that's party music. I can understand if you hear it for the first time, in 1945 or 1946, and you're kind of confused—"I don't know what kind of music this is, I don't know what they're doing." But you can't call it party music. You have to call it high artistic content.

Josephine Baker and so many musicians left the US and moved to Europe—I mean, it's a long list of people.

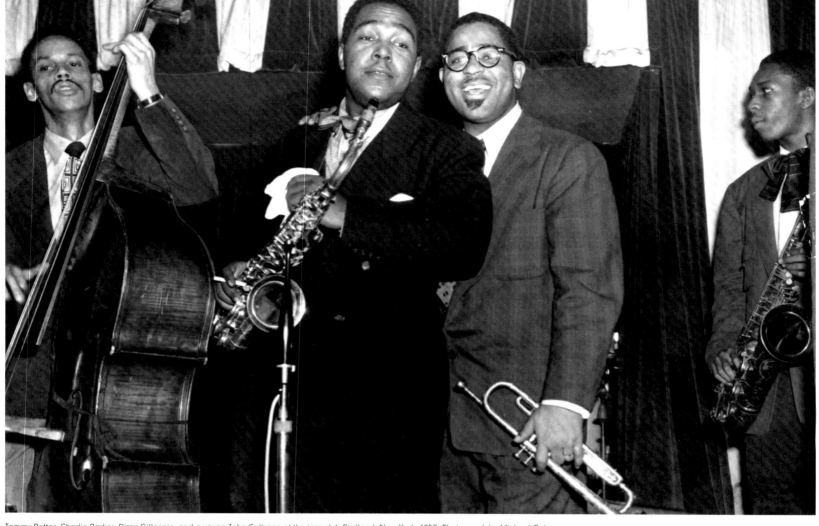
Tommy Potter, Charlie Parker, Dizzy Gillespie, and a young John Coltrane at the jazz club Birdland, New York, 1950. Photograph by Michael Ochs

Kenny Clarke and Bud Powell went over there. They had to get away from the intense in-your-face fire of racism in America. And France has always been ahead of the curve in terms of the arts, particularly with music—the French understand the deep meaning of art. France would have been the perfect place to go at that time. That being said, France was not perfect, because everywhere had their own versions of racism that Black artists had to deal with.

AM Many visual artists have been inspired by jazz: Romare Bearden, Stuart Davis, Franz Kline, Norman Lewis, Piet Mondrian, Rose Piper, Jackson Pollock, Frank Stella, and others. More recently artists such as Jean-Michel Basquiat, Robert Ryman, and Stanley Whitney have cited jazz as a dominant influence on their compositions. These are just a few examples, but I wonder whether you have any thoughts on how music has helped shape painting and the visual arts, or how the visual arts have shaped music.

CM When you look at the shape of a work that a visual artist makes, it really is not that different than jazz improvisation because jazz improvisation can go to a lot of different places. It goes up, down, betwixt, between, loud, soft, medium, rigid.

And I think that visual artists are influenced by that. They're not so much influenced by more popular styles of music because those styles can get very formulaic. You know exactly what's coming, you know when it's coming, and you know how it's coming.

I believe to the average listener that's a good thing. They don't necessarily need a challenge when it comes to music. But artists tend to be deep thinkers—that's why they would be inspired by jazz. And, vice versa, there's a lot of jazz that has been inspired by visual art. So it goes hand in hand.

AM In 1947 Dizzy Gillespie and Chano Pozo premiered "Manteca" at Carnegie Hall. This song prompted the development of Afro-Cuban jazz. What thoughts do you have about this touchstone and its continued importance today?

CM Dizzy Gillespie was so important. He was an innovator of the highest order. He was one of the co-creators of bebop—and within two or three years, he's also ushering in music from another place, which in turn started an entire new genre and tapped into music that America didn't yet know about.

Now, obviously, there had been Puerto Ricans and Cubans living in New York. But Chano Pozo was to Cuban music what somebody like Charlie Parker was to American music. And the fact that they came together at that time—Dizzy Gillespie had the foresight to see Chano Pozo and say, "Americans need to hear this."

There are a lot of musicians in the genre of what some would call Latin jazz. Dizzy Gillespie is their god, because if it weren't for Dizzy Gillespie that music might not have gotten a broader listening base. So what Dizzy and Chano did together, of course, that spawned the possibility of stardom for people like Tito Puente, Tito Rodríguez, Charlie Palmieri and his little brother Eddie, and Mongo Santamaría. It's just amazing what an innovator Dizzy Gillespie was.

AM During this era, so much was lost in the destruction of the war. Do you have any thoughts about lost histories and the power in the stories that we carry forward, versus those that we move on without, and the ways history gets written?

CM That's a very interesting question, because I feel like the times that we live in right now—when people read the history of this time forty or fifty years from now, I wonder if they'll believe it.

I feel like capturing people's stories is one of the most important things anyone on this Earth could do. When you're a kid, you're constantly dismissive of things your parents or grandparents say to you. But I would give anything to go back in time and record them and be able to say, "Here's some of those stories that my grandparents, great-aunts, and great-uncles would tell me," because when you get older you are curious about history. What happened? How did you deal with it? You can't ask them now. Instead of reading some interpretation, you could get it direct from the people who were there. And there aren't a lot of people left who were alive during World War II.

But it's also good to go back and read old books. And you can't worry about being offended by what someone wrote in 1940. That's how they thought in 1940. It's very dangerous to wipe out stories simply because we don't like them. That's very shortsighted. And it celebrates a certain type of ignorance. It's important to preserve the stories even if we don't like them.

AM In the 1990s a lot of jazz was being sampled in early hip-hop records. As a young jazz musician rising to prominence at that same moment, was there anything particularly exciting about seeing those two genres coming together?

CM When there's something new, when something truly innovative is going on, people have to understand that it is often not instantly embraced, because people don't know what it is. In retrospect, we ask questions like, "How could people not like bebop? How could people not like what John Coltrane was doing?" That's because we've had decades to let it distill.

But when things are happening in the moment and you don't really know what they are, you also don't know if they're going to last. You don't know if it's going to stay. You're not even sure if you like it or not. So when A Tribe Called Quest first came out, and Guru started doing his Jazzmatazz projects, and Stetsasonic started

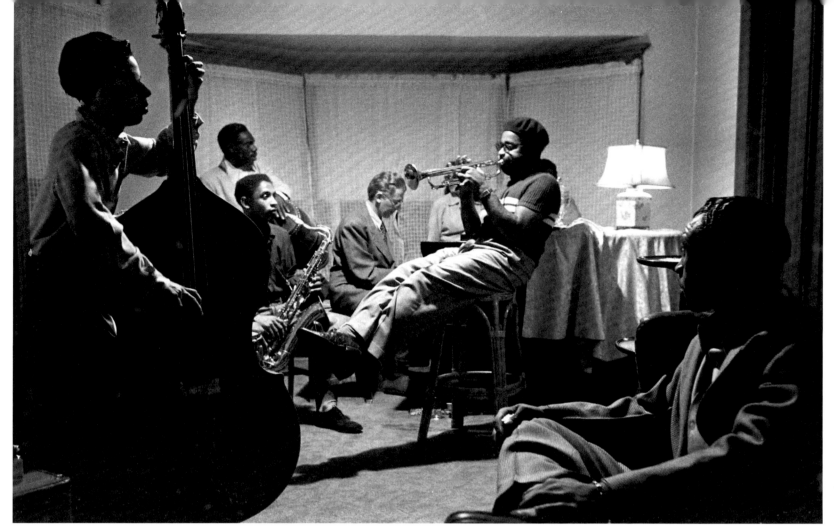

Dizzy Gillespie, 1948. Photograph by Allan Grant

Chano Pozo, 1948. Photograph by Allan Grant

doing their projects, I personally thought it was very cool that they were sampling jazz records. And, of course, in Tribe's case, they were actually using jazz musicians on their record. It gave Ron Carter an unbelievable career boost. But at the time, I was not really one of those people who thought, "Oh, I'm going to jump on this because it's so innovative." I had gigs with legendary masters already at that point. So it wasn't in my best interest to jump on something that was trending. It was in my best interest to get as much information as I could from those musicians that they were sampling. And then, of course, growing up with somebody like Questlove, I always felt like my finger was on the pulse of what was going on. So I wasn't completely out of the mix.

But, yes, it was a very, very exciting time. And, of course, what we know now is that innovation most definitely did stick. And you see what people like Common, BJ The Chicago Kid, and Tyler, The Creator are doing now. They care about jazz, and I hope that happens more often.

AM What advice do you have for the next generation of musicians who are just starting their careers?

CM For the next generation of musicians—listen, read, and ask questions. Listen to as much music as you possibly can, read as much as you possibly can, and ask questions as much as you possibly can. It's nice to have a vision. It's nice to feel like you've got something that you want to present to the world, but always try to gather more information.

Christian McBride is an American jazz bassist, composer, and arranger.

Alison McDonald is the Chief Creative Officer at Gagosian and has overseen marketing and publications at the gallery since 2002.

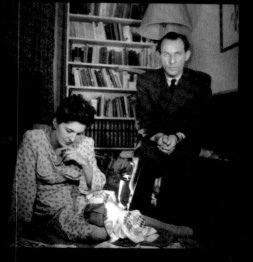

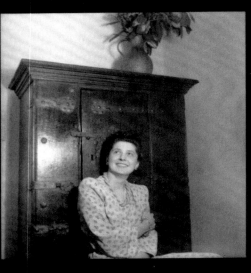
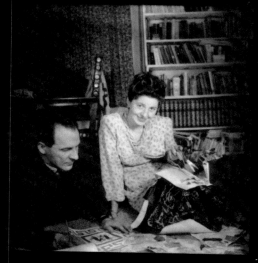

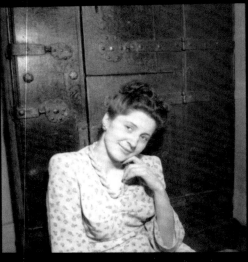

LIDA AND ZIKA ASCHER, 1940S. PHOTOGRAPHS BY FRANCIS GOODMAN

LEFT: BARBARA HEPWORTH, "LANDSCAPE SCULPTURE" SCARF, 1947;
RIGHT: SALVADOR DALÍ, "LEAF HANDS" TEXTILE, 1949

ART IN THE HOME

Painting by the Yard

Following the onset of war in Europe and the Pacific, the United States saw an unprecedented growth of interest in art, with a third of contemporary art sales in 1943–44 made to new collectors. Art galleries and artists looked for opportunities to expand their share of the burgeoning market, while textile manufacturers and converters sought out fresh and inspiring designs to replace the traditional subject matter that dominated apparel and furnishing fabrics at all price points. These intersecting interests resulted in collaborative projects aimed at incorporating contemporary art into everyday life. The initiative was not limited to the United States; Great Britain, with its long history of manufacturing fine printed textiles and promoting original textile design, took the lead.

Lida and Zika Ascher, Czech émigrés, had relocated to London in 1939 and three years later founded Ascher Ltd. Their company supplied high-quality dress fabrics to couturiers worldwide that were praised for their inventive designs. Zika Ascher reimagined the ubiquitous head scarves that dominated wartime fashion and turned them into works of art. Beginning in 1944 he commissioned leading British and French artists to closely collaborate with him on hand-screenprinting large squares that could be worn as scarves or framed and hung on the wall as works of art (his first such collaboration was with Henry Moore). Thirty-seven of Ascher's Artist Squares were framed as paintings and exhibited at London's Lefevre Gallery on Bond Street in 1947. They were shown throughout Britain as well as worldwide, including in the United States as part of a traveling exhibition organized by the Museum of Modern Art in the winter of 1949–50.

The British sculptor Barbara Hepworth's "Landscape Sculpture" (1947) from this series drew on her earlier experience as a textile designer. She and her husband, the artist Ben Nicholson, had experimented with block-printed fabrics during the 1930s. The flat planes of "Landscape Sculpture" are enlivened with irregular lines. According to the artist, "Textile designing is more than patterning. Colour and form go hand in hand—brown fields and green hills cannot be divorced from the earth's shape—a square becomes a triangle, a triangle a circle, a circle an oval by the continuous curve of folding: and we return, always, to the essential human form—the human form in landscape."[1]

The influence of modern art on contemporary living continued to dominate museum exhibitions and department store installations throughout the late 1940s. In June 1949 Schiffer Prints Division of the Mil-Art Company launched the Stimulus collection of furnishing fabrics for drapery, slipcovers, and upholstery. *The New York Times* praised it as "unquestionably the most brilliant single collection of all modern prints introduced since the war."[2] The three collections released in 1949 and 1950 were by six designers—George Nelson, Ray Eames, Abel Sorenson, Bernard Rudofsky, Edward J Wormley, and Salvador Dalí—representing architecture, interior and industrial design, and the fine arts. They were chosen for the "specialized viewpoint" each could bring to textile design. Dalí was selected for his famed gifts of color and craftsmanship. Schiffer's second Stimulus collection included the artist's "Leaf Hands" design. Available in two colorways, it features the hands of a woman, leaf veined, the nails tipped with polish. The surreal pattern referenced Dalí's noteworthy collaboration with Elsa Schiaparelli for her winter 1936–37 collection, which included suits with bureau drawer fronts worn with gloves with red snakeskin fingernails.[3] Gloves with painted veins were also included in that season's collection.

Dilys Blum is the Jack M. and Annette Y. Friedland Senior Curator of Costume and Textiles at the Philadelphia Museum of Art.

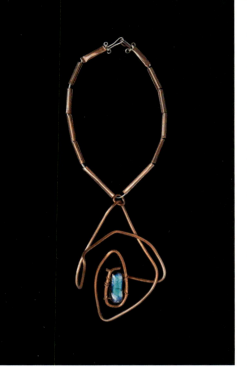 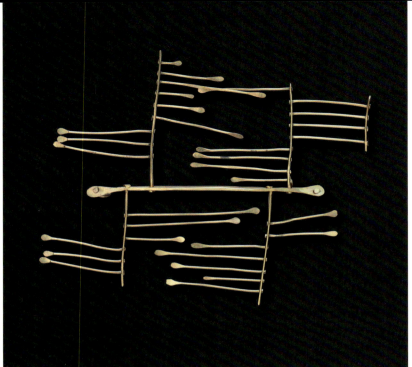 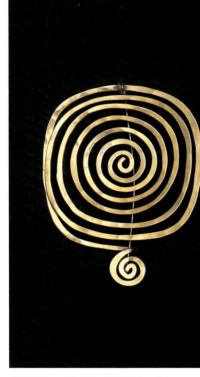

ELSA FREUND, NECKLACE, 1948 **HARRY BERTOIA, BROOCH, c. 1947** **ALEXANDER CALDER, BROOCH, c. 1940**

MAKE IT DO

American Modernist Jewelry

Those who lived through the Great Depression that marked the beginning of the 1940s were accustomed to rationing goods and materials, and creatively using or reusing what was on hand for other means, essentially practicing what we now call repurposing or upcycling. Depression-era folks employed various expressions to capture their living conditions: "a make-do existence"; "out of necessity"; "out of nothing"; "on a shoestring." The Depression-era slogan "Use it up, wear it out, make it do, or do without" was adopted by the War Advertising Council during World War II to promote the need to conserve resources to lessen the demand for goods and keep prices down.[1]

Improvising was foundational for the artists who continued to create through the war years. Despite strict rationing of metals needed for the war effort, artists of the nascent studio jewelry movement found innovative ways to get what they needed, using scrap metal and alternative materials to make their handcrafted jewelry. Alexander Calder, born into a family of sculptors, was an important figure in the movement, and had an early predilection for repurposing found materials. When he was just eight years old, he used copper wire discarded on the street by workmen splicing cables to make jewelry for his sister's dolls.[2] The inventive and expressive jewelry he created throughout his life—made by shaping various industrial gauges of silver, steel, brass, and occasionally gold wire—can be considered as from the same wellspring as his early wire sculptures, mobiles, and stabiles. One such example, a brooch formed of brass and steel wire, appeared in his jewelry inventory book of about 1941 and remained in his repertoire for several years.[3]

Another notable figure in the studio jewelry movement was Harry Bertoia, an émigré from Italy. A gifted art student drawn to metalwork, he was accepted into the Cranbrook Academy of Art in Bloomfield Hills, Michigan, in 1937 on the condition that he reinstate their metalworking studio, a task he accomplished in 1939 (he would teach at the academy until 1943). A brooch from about 1947 is an example of his jewelry from the end of the decade. Like many metalsmiths and sculptors working during wartime, Bertoia had turned to making jewelry from scraps, which he found around the metals shop at Cranbrook, employing a technique of "drawing" the scrap metal through holes in a steel plate to fashion his own wire.[4] His brooch's hand-hammered wire balances the more formal elements of this geometric composition, which foretells the large-scale constructions he would create beginning in the 1950s.

Elsa Freund grew up in rural Missouri in a family whose simple lifestyle required them to be imaginative and inventive in converting discarded objects into useful household items or art projects. In 1929, after graduating high school and while employed as a receptionist for a recreational boating company in Hollister, Missouri, she set up a space in the reception room where she displayed her first assemblage of jewelry—bracelets, necklaces, and belts made from pods, nuts, peach seeds, and shells.[5] After studying ceramics and glaze theory in the early 1940s, Freund began more serious jewelry making, including fusing glass with clay in an enameling kiln to create her own "stones," which her husband, Louis, dubbed Elsaramics. The glass came from ordinary household vases, various types of bottles, and old automobile taillights collected for the full range of colors they provided when fused. A necklace from 1948 is an unconventional combination of nonprecious materials composed into an instinctive, vibrant design that embodies the movement toward abstraction at that time. Freund threaded tubes of rolled copper sheet for the chain and formed a pendant of thick copper wire as if drawing in space, placing an oblong turquoise "stone" at the center. In 1953 she developed a line of jewelry sold in the Sea Chantey, a boutique on St. Armands Key in Sarasota Bay, Florida, that helped to popularize her work.[6]

Elisabeth Agro is the Nancy M. McNeil Curator of Modern and Contemporary Craft and Decorative Arts at the Philadelphia Museum of Art.

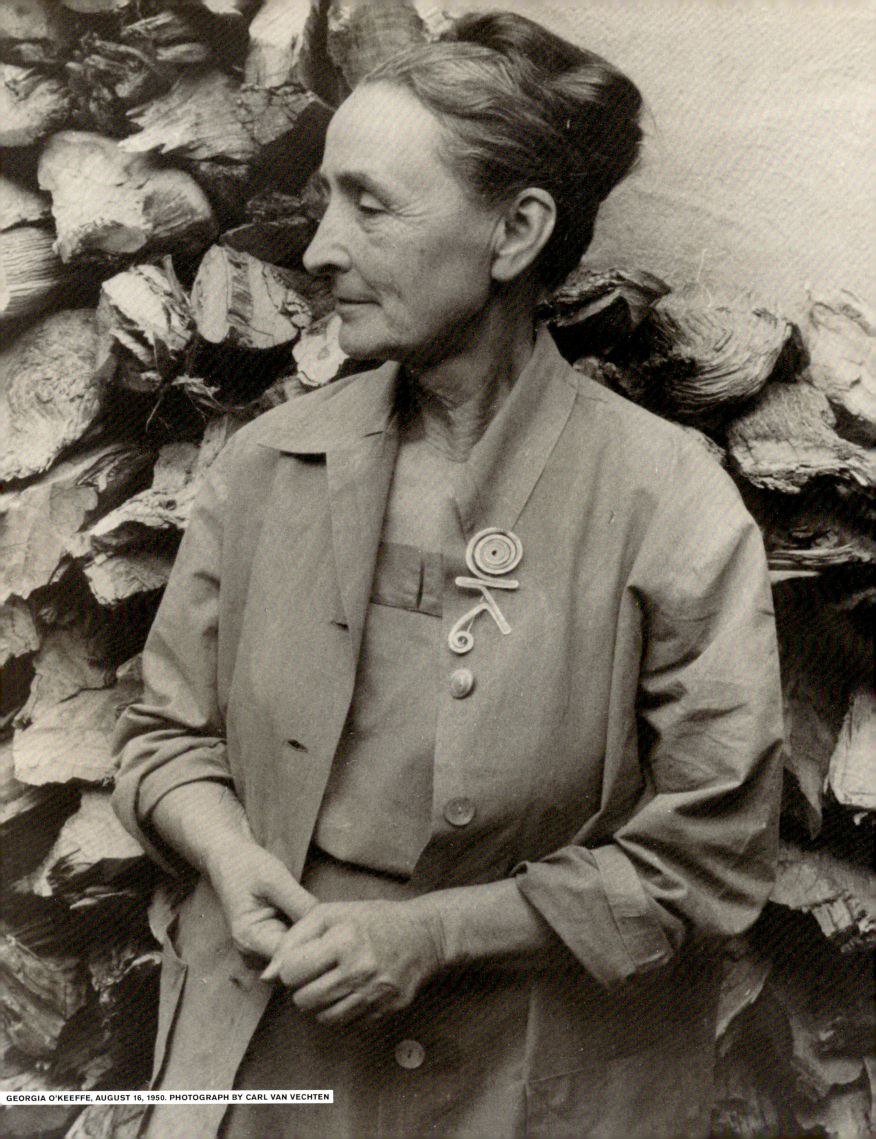
GEORGIA O'KEEFFE, AUGUST 16, 1950. PHOTOGRAPH BY CARL VAN VECHTEN

ARTISTS AND ALLIES IN THE 1940s

1 **PAUL CADMUS** *The Conversation Piece*, 1940

QUEER CONNECTIVITY

Themes of LGBTQ+ identities and affiliations are present, even prevalent, in the Philadelphia Museum of Art's collection of 1940s art and design. Queer and queer-adjacent artists of the early twentieth century connected in a myriad of ways—aesthetics, geography, friendship, sex, romance, politics, business, philosophy—resulting in a complex network of overlapping, interpersonal linkages. This labyrinth of queer connectivity and kinship manifested artistically, visible in portraiture of and by artists such as Romaine Brooks, Paul Cadmus, Beauford Delaney, Man Ray, Isamu Noguchi, Georgia O'Keeffe, and Carl Van Vechten. Many of these individuals had relationships that spanned decades before and after the 1940s, as some of the works included here demonstrate. Such lasting connections also meant that these artists collectively witnessed new methods of conversion therapy, the development of the Kinsey Scale, and the continued pathologizing classification of homosexuality as a mental illness, among other queer historical moments.

Though "queer" is now commonly used and accepted as an umbrella term to describe various types of sexually and gender nonconforming people, the term has a long and complex history, often wielded in the past as hate speech. The intention behind choosing queer identity as a thematic avenue of consideration includes respectful and compassionate recognition of this painful history, along with acknowledgment and understanding of the queer community's reclamation and celebration of the term over the past several decades. The dialectic of the word "queer" invokes the term's legacy of resistance, beginning in the 1960s and taking larger effect in the 1990s with the efforts of Queer Nation. Further, the open-endedness of the term allows more room for the inclusion of non-Eurocentric conceptualizations of sexual and gender nonconformity, such as Two Spirit identities in Indigenous American cultures and *hijra* communities in India. It is important to acknowledge that during the 1940s, the artists represented in *Boom: Art and Design in the 1940s* did not necessarily describe themselves or their work as "queer," though some, like Carl Van Vechten, likely would have. By that time, labels such as gay and lesbian were becoming more mainstream, as were slang terms such as "fruit," "bulldyker," and "friend of Dorothy."

LGBTQ+ is a shorthand version of the acronym LGBTQIA2S+, which refers to the lesbian, gay, bisexual, transgender, queer, intersex, asexual, and Two Spirit community. The "+" indicates the expansiveness of the community and the additional gender and sexually nonconforming identities not represented by the letters preceding it. The term "queer-adjacent" is used here to describe certain allied individuals who held long, close friendships or relationships with queer people along with those artists about whose queerness scholars disagree.

2 **BEAUFORD DELANEY** *Portrait of James Baldwin*, 1945

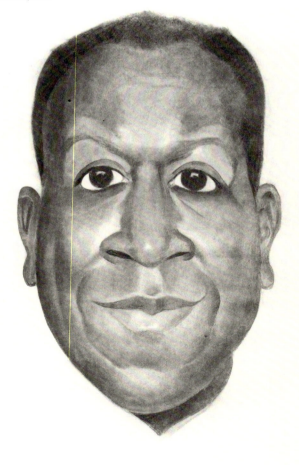

3 **GEORGIA O'KEEFFE** *Untitled (Beauford Delaney)*, 1943

4 **CARL VAN VECHTEN** *James Baldwin*, 1955

CONNECTIONS

Paul Cadmus often created blatantly (homo)erotic artwork featuring sexualized male figures with emphasized muscles and bulges. Though his work was frequently perceived as scandalous and was censored throughout the 1930s and early 1940s, Cadmus lived an indiscreetly gay lifestyle and became part of a tight-knit community of queer creatives in New York City. A preparatory drawing by Cadmus for a large painting, *The Conversation Piece* features three of the artist's close friends—Monroe Wheeler, Glenway Wescott, and George Platt Lynes—who were all in a romantic relationship at the time. Wearing only briefs, Lynes reclines like an odalisque, presenting his body for the gazes of his lover, the artist, and the viewer: a multilayered homoerotic gaze. Cadmus particularly directs our attention to Lynes via Westcott, the kneeling central figure whose line of sight traces directly down to his lover's bulge.

Similarly embedded in New York's gay scene, Charles Demuth continued to unite his fellow artists in memory through the 1940s (Demuth died in 1935). Late in his career, isolating in his conservative hometown and coping with serious illness, Demuth began making overtly homoerotic watercolor paintings of sailors, much akin to those created by Cadmus in the 1930s, because he had become less concerned with abiding by homophobic obscenity laws at the end of his life. He bequeathed all his oil paintings to his friend Georgia O'Keeffe, with whom he had grown close in New York as a similarly singled-out "effeminate" member of Alfred Stieglitz's circle and pioneer of Precisionist painting.

Deviating from such modernist styles, O'Keeffe's drawing of the painter Beauford Delaney, one of five portraits she made of him, is highly realistic and deeply personal. O'Keeffe was seldom a portraitist—only ever depicting Delaney and Stieglitz's niece—and her focused, true-to-life representation of her fellow artist evidences her fondness and admiration for him. The catalogue for Delaney's 1973 solo exhibition in Paris included a tribute by O'Keeffe in which she describes Delaney as "a very special person—impossible to define."[1]

At the forefront of the Harlem Renaissance, Delaney had no shortage of artistic and intellectual connections. He was lifelong friends with the prolific author and activist James Baldwin, with whom he had a close, father-son-like bond. Despite their twenty-three-year age gap, they shared several core characteristics beyond their similar backgrounds as sons of Southern preachers: both were gay Black men living and working in New York City. Delaney emphasizes Baldwin's youth and dynamism in his 1945 portrait of the author. Stylistically rendered with energetic brushstrokes, bold lines, and vibrant shades of primary colors, the closely cropped image shows Baldwin with wide, alert eyes that stare out into the potentials of the future. Distinguished from a darker red on the right, the light red background surrounding the figure's head like a halo appears to be radiating away from the darker portion, carrying Baldwin with it.

Carl Van Vechten's 1955 photograph of Baldwin has similarly holy visual connotations. Less closely cropped than Delaney's, this portrait of Baldwin portrays him from the thighs up, wrapped in the drapery that hangs behind him in a manner that suggests he is wearing a hooded robe. This "attire," in combination with Baldwin's hands, which are pressed together in a gesture of

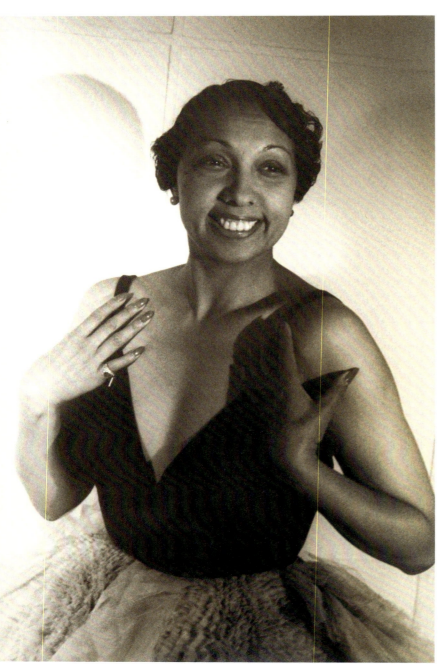

5 **CARL VAN VECHTEN** *Josephine Baker*, 1949

6 **ROMAINE BROOKS** *Carl Van Vechten*, 1936

7 **CARL VAN VECHTEN** *Natalie Clifford Barney*, 1935

prayer, seems to have monastic implications. Beyond this, the overexposed center of the photograph creates the illusion of a holy light emanating from Baldwin's chest. Instead of the wide-eyed youth from Delaney's portrait, Van Vechten gives us a Wise Man. Primarily a critic and writer until the 1930s, when his devotion to artistic photography began, Van Vechten was particularly interested in uplifting the work of Harlem Renaissance creatives, nearly all of whom he photographed between 1930 and 1960. Many, if not the majority, of the most prominent and acclaimed figures of the era—including Josephine Baker, Beauford Delaney, Langston Hughes, Alain Locke, and Bessie Smith—were also part of the LGBTQ+ community, like the photographer himself. In fact, Van Vechten felt Harlem was where he could be most open about his queerness.

Van Vechten's fascination with Blackness spanned his entire life. Many praised the photographer and credited him for bringing legitimacy to Black art, music, and literature for a white audience. Others, including W. E. B. DuBois, criticized Van Vechten and his literary and photographic output, considering his fixation to be problematically voyeuristic. The expatriate painter Romaine Brooks's 1936 portrait of Van Vechten connotes the insidious nature of his fetish. At first it appears to be a straightforward depiction of the white photographer, who wears a white suit that contrasts strongly with the dark background. But upon closer inspection, we find the disembodied faces of Black men eerily looming behind Van Vechten. Brooks was among the many queer American women living fairly openly in Paris during the first half of the twentieth century, such as renowned lesbians Natalie Barney and Gertrude Stein. Van Vechten knew and photographed them all, including fellow photographer Berenice Abbott.

8 **CARL VAN VECHTEN** *Berenice Abbott*, 1937

By the time Van Vechten photographed Abbott, she had already moved back to New York from Paris, where she first learned about photography from the Dada and Surrealist artist Man Ray. Upon arriving at the French capital in 1921 and desperate for work, she happened to bump into Man Ray, whom she knew from earlier years in New York, and became his darkroom assistant. Man Ray taught her his own technique and style, and soon enough Abbott became a sought-after portrait photographer in her own right: to be photographed by Abbott became a symbol of status among the cultural elite in Paris. Abbott believed that authentic portraits are the product of a reciprocal exchange between artist and subject.[2] Her portraits of fellow queer Americans such as Jane Heap are particularly evocative, given Abbott's ability to more fully identify and empathize with their common lived experiences.

Man Ray was not thrilled when demand for Abbott's work began overshadowing that of his own, but he nevertheless stayed in Paris until the beginning of World War II, when he made the decision as a Jewish man to return to the United States, this time moving to Hollywood. It was in California that he connected with the social realist painter George Biddle and began collaborating on reciprocal portraits. Biddle's large-scale portrait of Man Ray, painted in 1941, includes a representation of the latter's painting *Leda and the Swan*, paying homage to his Surrealist style of art making. Of this choice, Biddle commented, "Man was enthusiastic about my suggestion for incorporating in the picture a series of Surrealistic emblems as the proper *mise en scène*."[3] These props include a horse skull, a gnarled piece of driftwood, and a draped white cloth with which two tuxedo kittens play. For his part, Man Ray provided a moment of portraiture inception: a

9 **BERENICE ABBOTT** *Portrait of Jane Heap*, c. 1928 (printed 1982)

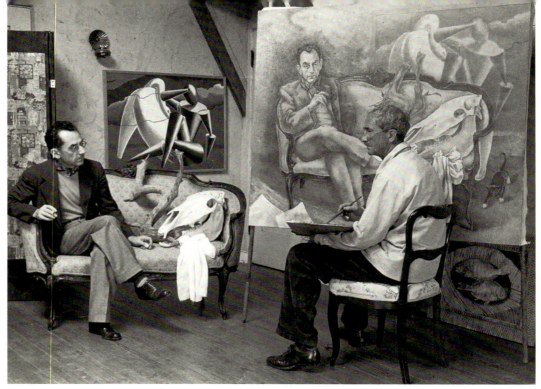

10 (top) **MAN RAY** *George Biddle Painting a Portrait of Man Ray*, 1941 11 (bottom) **GEORGE BIDDLE** *Portrait of Man Ray*, 1941

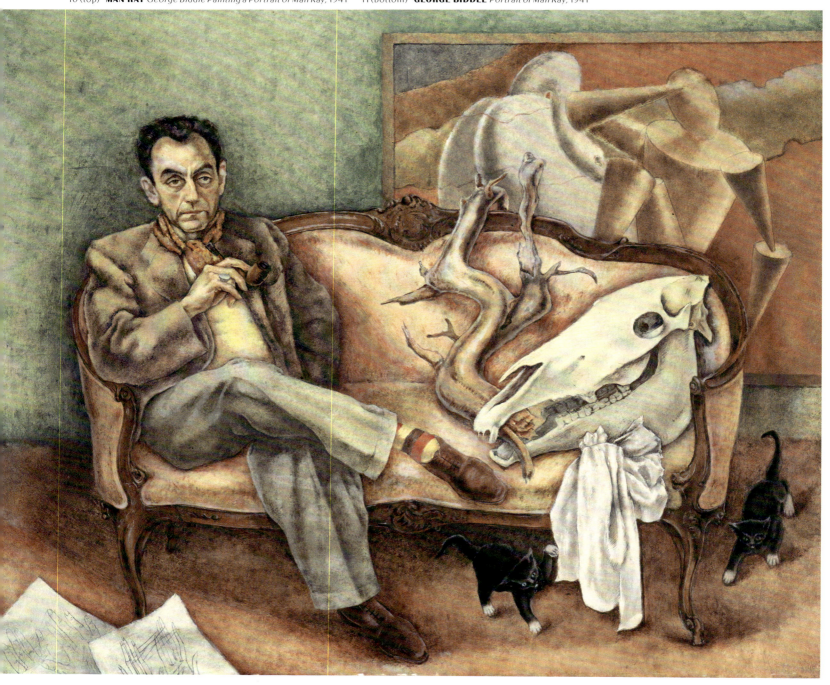

photo of Biddle finishing *Portrait of Man Ray* as Man Ray poses on the couch.

Close friends since childhood with Franklin D. Roosevelt, Biddle helped establish the Federal Art Project of the Works Progress Administration. It was through this program, lasting from 1935 to 1943, that he first became acquainted with the sculptor and designer Isamu Noguchi. The two became close enough friends that Noguchi wrote to Biddle shortly after arriving at the Poston War Relocation Center, one of the internment camps set up by the US government to detain those of Japanese descent during World War II. Otherwise exempt as a resident of New York, Noguchi volunteered to enter the camp on principle, and remained there for six months; in George Platt Lynes's 1938 portrait of the queer sculptor, one can discern the idealism that would later drive Noguchi to his decision. Shot from a low angle, we see Noguchi from the hips up, standing in front of a patchy, light-colored background reminiscent of a slightly cloudy sky, with a kite-like vertical sculpture at the right. The combined effect is of an openness that seems indicative of the subject's sensitivity and broad-mindedness.

While Lynes's portrait of Noguchi lacks the homoeroticism for which much of his work is known, his portrait of Paul Cadmus has an entirely different vibe. Also shot from below, Lynes's photograph of Cadmus is stark and confrontational. Tilting his head back as if to accentuate the degree to which he looks down at the viewer, Cadmus seems to engage in a scrutinizing play of sexual power. The high contrasts between light and dark emphasize this effect by adding a sense of severity and sternness. Cadmus and Lynes are, of course, the artists with whom this exploration of connectivity began. In teasing out this one strand of connections—both beginning and ending with Cadmus and Lynes—from a much larger web, we can readily observe the multifarious and overlapping ways in which queer and queer-adjacent artists from the first half of the twentieth century related to one another personally and artistically. This case study similarly helps to convey the ubiquity of LGBTQ+ art and identity within American modernism. Such observations help to combat the notion that queer identity and connectivity are isolated phenomena and not, in fact, a part of all art histories. In this case, queer portraiture and American modernism are revealed as two sides of the same coin, meaning that queer art history turns out to be... art history.

Lily F. Scott is the exhibition assistant for Boom: Art and Design in the 1940s *and a doctoral candidate at Temple University in Philadelphia.*

12 **GEORGE PLATT LYNES** *Isamu Noguchi*, c. 1938

13 **GEORGE PLATT LYNES** *Paul Cadmus*, c. 1940

ABOVE: HORACE PIPPIN, *THE PARK BENCH*, 1946; BELOW: "DOUBLE VICTORY" FROM THE FRONT PAGE OF *THE PITTSBURGH COURIER*, FEBRUARY 7, 1942; OPPOSITE: HORACE PIPPIN, *MR. PREJUDICE*, 1943

FROM WAR TO PEACE

Horace Pippin on the Home Front

Human rights and social issues are recurring themes in Horace Pippin's work, but his 1943 painting Mr. Prejudice is particularly overt in its treatment of racism, while alluding to wartime. Pippin had served in World War I in the 369th Infantry Regiment, a division of Black soldiers known as the Harlem Hellfighters. The unit was assigned to the French army because so many white American soldiers refused to fight alongside Black servicemen. Stationed on the front line, Pippin sustained serious injuries to his shoulder, neck, and arm.[1] He was treated at a French hospital and honorably discharged.

During the war Pippin made drawings of his experiences, a practice he continued afterward, particularly following his return to his birthplace of West Chester, Pennsylvania. He began his first oil painting in 1930 and gradually developed a distinctive technique and style. By the time he painted Mr. Prejudice, Pippin had been "discovered." He made his national debut at the Museum of Modern Art in 1938 and had several solo exhibitions, gallery representation, and important collectors interested in his work. Against this backdrop of professional accomplishment, his country was once again enmeshed in global conflict, and his stepson served in the military. The turmoil of his own war years may well have weighed on his mind.[2]

He and his fellow Black soldiers were not treated as heroes when they returned from combat. Segregation persisted, and there were several lynchings of Black soldiers in uniform. Racial inequities and clashes continued unabated through the start of World War II, threatening the war effort to such an extent that President Franklin D. Roosevelt was compelled to intervene.[3]

In Pippin's painting, clouds hover over a hooded member of the Ku Klux Klan and a burly white man holding a noose. The two menacing figures stand opposite the Statue of Liberty, painted brown instead of green. At the center, a white man wielding a mallet, presumably Mr. Prejudice, drives a wedge into a V that cleaves the composition in two, segregating white and Black machinists and servicemen. To the right of that divide, three white men wear World War II uniforms representing the US Air Force, Army, and Navy. They look toward four Black figures: a masked doctor or a patient swathed in bandages, two men in WW II attire, and one wearing an army uniform from WW I, possibly representing Pippin himself, with one hand on his hip and the other arm hanging by his side. The central V seems to allude to the V for Victory popularized by Prime Minister Winston Churchill of England as a symbol of hope and resistance against the Germans. Closer to home, the *Pittsburgh Courier* created a rallying cry around the "Double V," indicating the imperative for victory in the war abroad and triumph over discrimination in the United States.[4]

One of Pippin's postwar paintings, The Park Bench, was also one of his last, still in his studio at the time of his death in 1946. A solitary man sits on a red bench with autumn foliage and a white squirrel behind him.[5] The composition probably was inspired by a West Chester resident who liked to spend time in Everhart Park, just a few blocks from Pippin's home. The artist Romare Bearden, among others, felt it symbolized Pippin, "who, having completed his journey and his mission, sits wistfully, in the autumn of the year, all alone on a park bench."[6] Whether drawn from experiences, memories, or imagination, Pippin created works of power and poignancy that continue to inspire.

Jessica Todd Smith is director of Curatorial Affairs, and former Susan Gray Detweiler Curator of American Art, and manager, Center for American Art, at the Philadelphia Museum of Art.

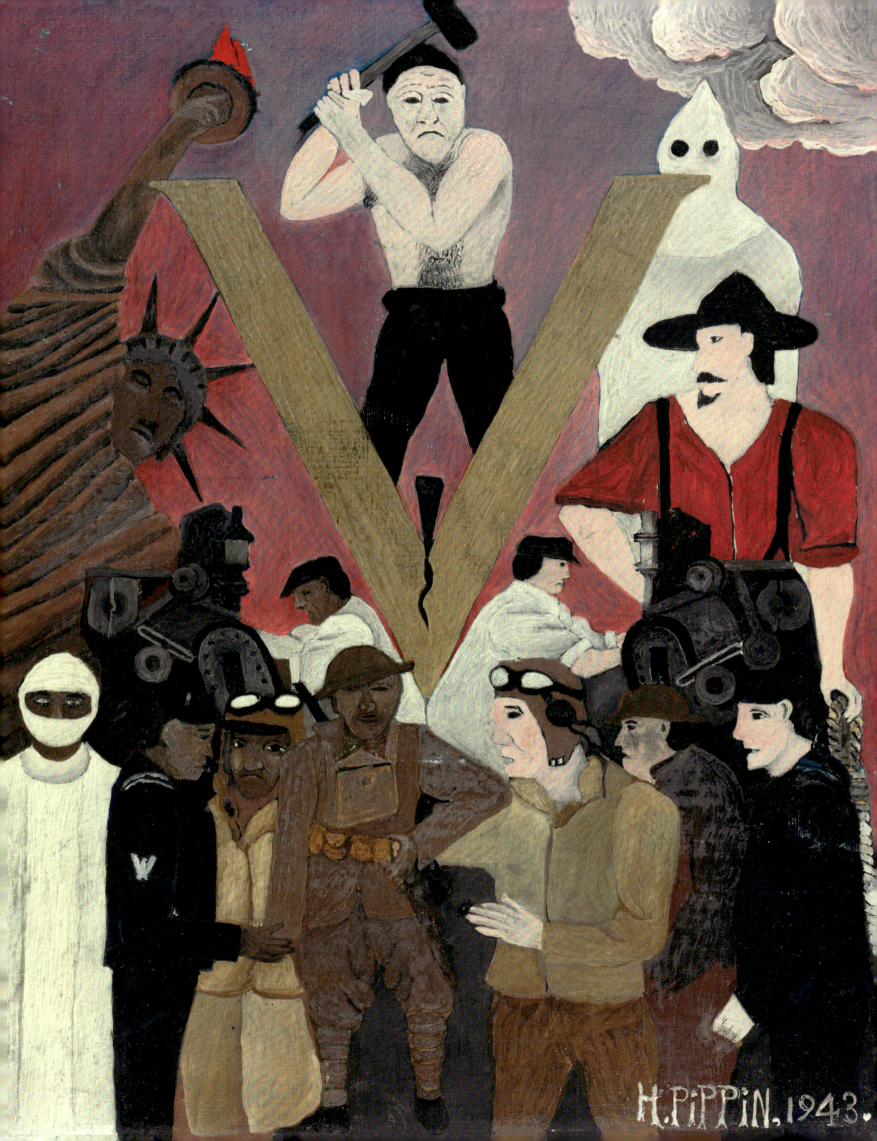

Fashion During Wartime

Elsa Schiaparelli
For her fall 1939 collection, Paris designer Elsa Schiaparelli showed suits with large pouch pockets suitable for wartime needs (see p. 14). The ensembles included a gray wool suit jacket with a slit skirt worn over tomato-red corduroy bicycle bloomers for cycling to the market, paired with a matching red hat, and an olive-green suit with a green slouch hat. From "New Way of Life in France," *Vogue*, December 15, 1939, p. 63. Sketch by Eric (Carl Erickson)

Wartime & Fashion

World War II mobilized fashion as an act of patriotism, extending into every household the changes that were codified and regulated by governments. The 1940s pulled away from the economic and social depression of the 1930s that had followed on the heels of the roaring twenties, whose exuberance had been an anesthetic to the horrors and enormous losses of World War I. H. G. Wells had described it at its start in 1914 as "the war that will end war," but tragically, this was not so. In fact, unsettled issues remained, underpinned by the conditions imposed on Germany in the Treaty of Versailles, which unintentionally fueled the fears and anger that led to World War II.

Fashion Shifts in Germany

The historian Irene Guenther described how the German fashion industry was already being Aryanized before the onset of war. Right-wing groups felt that German women were too influenced by French fashion, and the Jewish population was imbricated. As she wrote, "Now, the opportunity presented itself to silence Germany's trendsetting neighbor, to banish an 'overwhelming' and nefarious Jewish presence, and to produce a pure 'German fashion.'"[1] In the 1930s this was realized by Adefa, a garment manufacturers' union established to "purify" the fashion industry by eliminating Jewish participation at all levels. It was adopted in Nazi propaganda of *Volksgemeinschaft* (national or folk community), which encouraged an idealized Third Reich femininity of clean-scrubbed, fair women wearing dirndls and with their hair in braids.

In September 1939, when Hitler invaded Poland, France and Britian declared war on Germany. A year later *The New York Times* reported on new clothing restrictions for German Jews. Men permitted to emigrate were forbidden to leave the country with

In 1946 New York's Midtown Galleries approached Onondaga Silk Company to collaborate with their modern American artists. The screen-printed silks and rayons were used by American fashion designers in their spring 1947 collections. The model on the left wears a dress by Jo Copeland in a geometric abstract print by San Francisco watercolorist Dong Kingman called "Chickens in Squares," inspired by his painting *Back Yard*. New Englander Waldo Peirce's "Kittens at Play" print was based on his painting *Maternity*, depicting a cat suckling her kittens; it was selected by Sophie Gimbel of Saks Fifth Avenue for a ready-to-wear dress. From "Painters' Prints," *Vogue*, January 1, 1947, p.124

more than two suits, a pair of overalls, one sweater, and one coat. Jewish women were allotted a similarly limited wardrobe and were responsible for family provisions such as sheets and cleaning rags. For the majority of the Jewish community who remained, a 9:00 p.m. curfew was imposed, and shopping for anything was curtailed to one hour, making it difficult to complete due to long queues.

The Limitations of Industry During War

The war significantly altered industrial and manual production by redirecting resources to prioritize military needs, which were enormous. Endless supplies of wool and silk were required for uniforms, blankets, and munitions; cotton and linen for shirts, underwear, pajamas for the wounded, hospital bedding, bandages, and dressings. Metal was needed for weapons, vehicles, tanks, boats, planes, and even military buttons, buckles, and hooks. In parts of Europe and North America, civilian dress was regulated by government restrictions on textiles, and fashion was redesigned to be efficient in its use of cloth through pattern layouts that minimized waste and yardage. As the war dragged on, increasing fear of dwindling supplies spurred the development of new materials such as nylon, fiberglass, rubbers, and plastics, all of which would become integrated into the 1950s postwar lifestyle.

Paris Couture Under Threat

In Paris, the couture salons closed when the men who ran them enlisted for military service and the seamstresses evacuated. The October 1, 1939, issue of US *Vogue* featured thirty pages focused on the Paris fall imports being sold locally. Added was clarification that the designs were "created in the atmosphere of impending war ... and arrived here just before the outbreak of war."[2] Magazines now included "War Notes" from Paris and London. Readers learned how French women were adapting, what they were wearing in the Ritz hotel air-raid shelter or at the restaurant Maxim's, in ensembles by Molyneux and Robert Piguet, and that "one often bicycles, one needs pockets, one needs bicycle bloomers," as the December 15 issue of the magazine reported. As the Phoney War (an eight-month period at the start of the war when there were virtually no Allied military land operations on the Western Front) continued, some couture houses reopened and struggled to "keep the wheels of France's industry in running order."[3] Others, notably Vionnet and Chanel, closed.

Accessories were defined by the war—large shoulder purses carried gas masks, torches, identification papers, money, ration coupons, first aid supplies, and whatever else could be stuffed in for warmth and protection when the air-raid sirens roared. Londoners and Parisians learned that wearing luminous buttons or trims and anything white at night helped "avoid head-on collisions while groping through inky blackouts," as *Vogue* announced on November 1, 1939. By 1941 torches and waving white handkerchiefs were essential as blackout fatalities rose, even though only 11 percent of cars on the road were civilian vehicles.[1]

In June 1940, Paris was occupied by German forces and closed to foreigners. Couture sales and exports were limited to Germany, Italy, and Spain, and the Allies were shut out from fashion news. The Third Reich dictated what couturiers could design by limiting the number of models, controlling materials, and restricting yardage. Without imports—wool from Australia, cotton from the United States, silk from Asia—couturiers often had to work with flimsy ersatz rayon and fibranne (spun rayon). The couturière Alix showed *tricoleur* fashions and would not fill orders for Nazi officers' wives. In retaliation, she and the Spanish designer Balenciaga were temporarily closed. In 1941 Germany issued couture ration cards to control sales; 200 were reserved for Germans, with the other 20,000 given out to private clients, commissionaires, and resident buyers. Paris couture continued.

The Home Front in Britain

The Blitz, a German bombing campaign in the UK that included nighttime attacks, began in September 1940 and continued until May 1941. In June 1941, the Board of Trade created a new rationing coupon system covering civilian clothing and household goods, in order to direct much-needed materials and labor to the war effort. However, it was not a strong enough measure, and a year later the Utility Clothing Scheme was introduced to not only curb production and labor, but also control the quality and quantity of materials being used.

Utility fashions were made from government-approved textiles: 102 cottons and 69 rayons with standardized weaves,

weight, and thread count. They were tested for shrinkage and washability and so were trustworthy, and of good quality. Styling was influenced by regulations that did not permit "frills" such as cuffs on men's trousers and cut two inches off men's shirts. It reduced the number of pockets, pleats, seams, buttons, buttonholes, and hem allowances for womenswear. British ready-to-wear makers who met the manufacturing regulations and controlled production, including Marks & Spencer, identified the clothes with a CC41 (Civilian Clothing 41) label. The novelist Barbara Cartland complained that everything at the time was rationed except, possibly, love.

To demonstrate to the public that it was possible to have attractive fashion under the Utility Scheme, members of the newly created Incorporated Society of London Fashion Designers (IncSoc) were invited to design Utility fashions. For spring 1942 each member produced a collection of four garments for mass production that promoted British fashion locally and abroad. The success of the Utility Scheme was reported to have saved four million square yards of cotton annually and 250,000 tons of shipping, and freed 400,000 men and women for war and war-related work.

The Mobilization of the American Fashion Industry

On December 11, 1941, the United States declared war on Germany, only days after the surprise Japanese attack on its military base at Pearl Harbor. On April 10, 1942, the US War Production Board (WPB), along with the Office of Price Administration, implemented General Limitation Order L-85, which was "deemed necessary and appropriate in the public interest and to promote the national defense."[5] As in Britain, the point was to channel 75 percent of civilian materials and labor to WPB essentials.

But converting civilian clothing factories to wartime production was challenging. Most of the fashion industry was geared for "soft" women's garments that did not require the special machines army and navy contracts demanded. Work was organized in a tailoring system whereby a skilled worker made a single garment. The government wanted to award contracts for sectional production that employed lower-skilled operators who were paid less to perform single or limited tasks. This meant government contracts paid less than civilian contracts. Changing factory systems and

Edward Molyneux
For British couturier Edward Molyneux's spring 1941 collection, photographer Cecil Beaton created an unsettling scene in which the model, standing in an abandoned room wearing a silk satin evening gown, seems about to be rolled up in the curling edges of the photograph. The shrouded chandelier and settee reference the homes left empty as people fled heavily bombed cities for the countryside or went abroad for the duration of the war. From "London Designs, America Imports," *Vogue*, April 15, 1941, p. 75. Photograph by Cecil Beaton

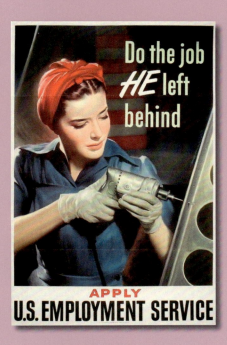

Rosie the Riveter was a media icon created to aid the war effort. This 1943 propaganda poster, designed by Robert George Harris in the US Office of War Information, encourages women to fulfill their patriotic duty and "Do the job HE left behind" by depicting a young woman confidently wielding a rivet gun while wearing functional overalls, work gloves, kerchief, and feminine makeup.

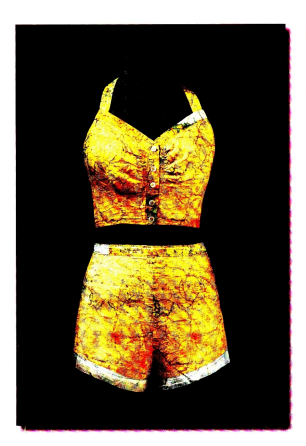

This two-piece swimsuit by an unknown maker was created from a recycled map of China showing escape routes. Silk and artificial silk maps, which could be unfurled without making a sound, were carried by pilots in case they were downed during a mission. Philadelphia Museum of Art

On this screenprinted silk scarf of 1941–45 by Edward McKnight Kauffer, Marianne and Britannia, the French and British patriotic symbols of strength and resistance, are unified in profile and enclosed by the phrases "Vive la France," "Long live England," and "Together for victory." Philadelphia Museum of Art

training new labor caused huge losses and, initially, resulted in idle manpower.

L-85 restricted excess cloth for details such as cuffs, wool linings, interlinings, and elaborate sleeves. It limited extraneous design elements such as tucks, shirring, pleats, and attached hoods, so styles became slimmer and skirts shorter. The biggest change in menswear was from double to single breasted, a shift that helped make the two-piece suit, without vest, a modern look. It was left up to the manufacturer to work out how to accomplish this in styling. Fashion designers adjusted their designs, but some manufacturers were indignant as the restrictions made existing stock obsolete. They asked to be able sell what was already made up, but instead had to their modify garments to meet the new regulations.

Having declared war on Japan, the Allies were cut off from supplies of silk, a vital material for parachutes and ammunition. In 1938 the American firm DuPont patented nylon, a man-made fiber that was a silk substitute. The "story of the swim suit that went to war—and became a parachute" was one of "American resourcefulness and reliability—American enterprise at its best," *Harper's Bazaar* claimed in September 1943.[6] Cole of California, known for its bathing suits, owed their success to the designer Margit Fellegi, who developed stretch Matletex in 1936. During the war Cole converted its operation from putting swimsuits on the bodies of women to putting parachutes on the backs of airmen, and became the largest parachute manufacturer.

But silk was still indispensable for gunpowder bags. It was the safest material, as only silk burned fully without leaving dangerous residue smouldering in the gun barrel. There were drives for used stockings. It took four dozen pairs of silk stockings to make one powder bag for a 16-inch gun, so women were encouraged to "turn in all ... those old silk hose you were saving for rugs. ... Every time one of Uncle Sam's big guns booms, a powder bag is burned up," as *Women's Wear Daily* eloquently urged on November 27, 1942.

Make, Share, Mend

Home front culture was created by civilians becoming involved in the war effort. In its July 1940 issue, *Harper's Bazaar* asked, "What can I do?" The reply was, "One person cannot help a million people. One person can help another person. A million people can help a million others. ... Relief work is going to be a part of every day. ... You can give money. ... You can raise money. ... You can collect

old clothes."[7] The American Red Cross collected used garments (one donation included a "useful" mink coat) that clothed people across war-torn Europe. Garments were also made by volunteers in chapters across North America and came from manufacturers that kept their factories running. The Blankets for Britain appeal was for homeless children and families residing in air-raid shelters, emergency centers, and hospitals. By May 1943 the Red Cross reported that in eight months, thanks to volunteer makers and donors, it had mobilized more than three million garments for US Army and Navy hospitals and service members.[8] As the end of the war approached, the needs increased. The Red Cross had thirty million stockpiles of clothing and supplies, but warned it was a drop in the bucket against the enormous demand coming as hostilities wound down.

Governments controlled new clothing while also encouraging an ethos of feminine economy as patriotic. Fashion magazines ran articles, and Britain had official *Make Do and Mend* brochures explaining how to patch, darn, knit, remodel, and look after your clothes so they would last longer. The scarcity of materials stimulated ingenuity. Women salvaged downed parachutes and made clothes out of printed-silk escape maps used by pilots because they were lightweight and did not rustle if one ended up across enemy lines. Wool was unraveled and reknit. In the US, companies that manufactured feed sacks increased sales and competition by printing sacks with up-to-date "lively and gay" prints for "the glorification of farmer's wives' wardrobes or homes," as *Women's Wear Daily* reported on May 28, 1943. Women bought multiple bags in the same print to ensure they had enough length for dresses and furnishings.

Women in Trousers and Uniform

Cultural concepts of feminine roles were fractured by the war, as women increasingly took on men's work and their vital contribution to the economy became visible. But the recurring, centuries-old belief that women in trousers threatened the patriarchy continued. Trousers with center-front openings were considered scandalous but slacks with side openings less so, and with hip darts accentuating waists, they became acceptable for American informal leisure wear. Overalls hid female curves, but they were also like aprons, archetypal domestic feminine working garments. If, when, where, and how women wore trousers was an important, much discussed subject.

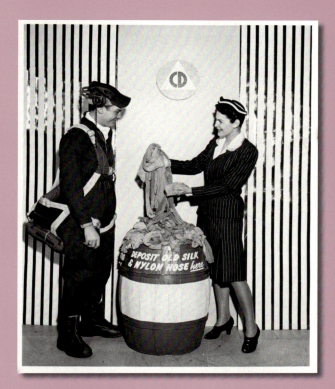

Silk and nylon were critical war materials, and thousands of salvage stations were set up in stores across the country to collect used stockings for reprocessing as parachutes, tow ropes for glider planes, and gunpowder bags. A technical sergeant in the US Army Air Corps listens as a civilian defense volunteer explains the source material for his parachutes.

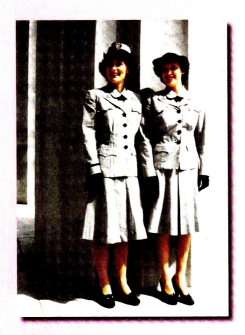

Mainbocher

Ensign Eloise English and Yeoman 3rd Class Virginia Laws pose in their smart WAVES uniforms at the Lincoln Memorial in 1944. Mainbocher described his design as combining "the dignity and tradition of the Navy ... [with] comfort, freedom and, of course, the lines of a woman's body" (*New York Herald Tribune*, August 29, 1942). The practical summer working uniform, a dress and jacket in pinstripe seersucker, was also washable.

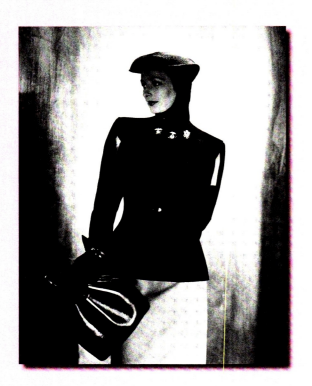

Adrian

This custom-made ensemble was created by American designer Adrian in 1946 for his new shop in Beverly Hills. The black jacket with rust-colored skirt in Pola Stout's Botany Perennial wools ensured that wardrobe colors continued to be harmonious over the years. From "A New Hand in the American Couture," *Vogue*, March 15, 1942, p. 63. Photograph by John Rawlings

Rosie the Riveter upended stereotypes. The moniker, originating in a 1943 song, was immortalized in Norman Rockwell's May 29 cover for *The Saturday Evening Post*, where she proudly demonstrated her capabilities in previously male-dominated industries. Shown in loose denim overalls, Rosie became an American workers' heroine. Her knotted kerchief, worn in place of a man's cap, was a feminine touch that also kept dangling hair out of equipment. Today Rosie remains a symbol of solidarity for working women.

Civilians were encouraged to travel by foot or bicycle, as gasoline and vehicles were prioritized for war. On October 15, 1939, US *Vogue* cautioned its readers that in Paris eccentricities were out of favor while simple, functional sports clothes were the norm, though "slacks are not yet worn on Paris streets even for bicycling." This was despite knee-length skirts that revealed legs while also allowing cold wind to blow up thighs. Elsa Schiaparelli showed culottes, and Jean Patou a warm ensemble with hooded cape and gas mask suitable for shelters. Civilians pulled out winter ski trousers for warmth in the air-raid shelters.

In May 1942 the first women were accepted into the US military. The male leaders had to come up with a uniform at a time when propaganda was telling women it was their patriotic duty to look feminine for the men overseas. To sidestep the "problem," the US Navy hired American couturier Mainbocher to design the first WAVES (Women Accepted for Volunteer Emergency Service) uniform in July 1942. The review in *Women's Wear Daily* on August 31 eulogized about the details of collar and lapel, and "the feminine but thoroughly practical side rolled hat." It was "feminine yet forthright and ... replete with military tradition and precision." It worked as separates, like American sportswear, with day, formal, summer, and winter blouse, skirt, and jacket, and even an evening skirt, gloves, and shoulder bag.

American Fashion Without Paris?

As the "needles of Paris" were suspended with the Nazi occupation, the direction of fashion was rudderless.[9] American buyers first turned to London for couture and to support the war effort, but the US began to drive its own fashion direction. In 1940 New York Mayor Fiorello La Guardia urged that the city should become the international center of the fashion industry.

The American fashion industry was in fact the largest in the world. Manufacturers, spread across the country, excelled

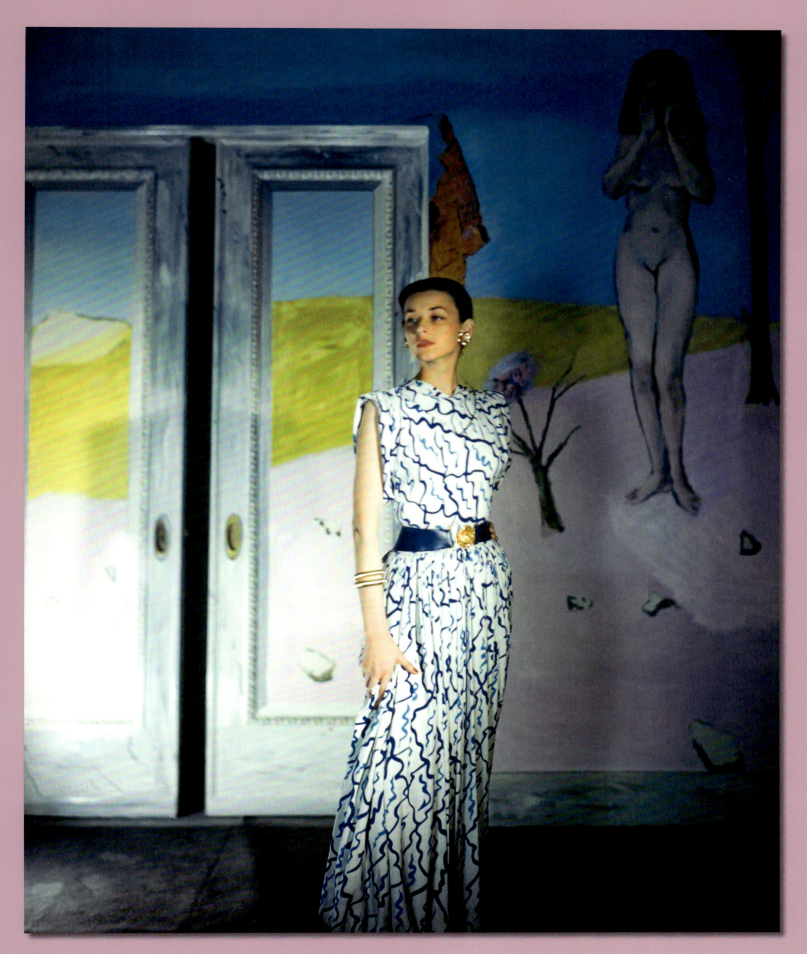

Omar Kiam
American designer Omar Kiam's abstract printed rayon crepe evening dress, made for the design firm Ben Reig, was for sale at Lord & Taylor and elsewhere. Photographer John Rawlings staged the shoot in front of the newly completed Marcel Vertès murals in the Carlyle Hotel in New York. From "1946 ... Vintage Year for Prints in America," *Vogue*, April 1, 1946, p. 163

in all levels of mass production. But American designers' names were not well known or promoted until the war. Best known were those who, since the 1930s, had made custom designs for an elite clientele, including Valentina and Charles James. Other custom designers worked in high-end stores that also sold imported Paris couture, such as Sophie Gimbel of Saks Fifth Avenue and Fira Benenson of Bonwit Teller, who then began their own lines. The entrepreneur Hattie Carnegie had her own specialty shops that combined Paris couture imports with her custom designs and ready-to-wear department.

On the West Coast, Hollywood disseminated the "American look" around the world with glamourous designs featured on-screen in black and white. Irene of MGM also designed for Bullocks Wilshire Salon in Los Angeles and developed a wholesale business. Adrian had a custom salon and went on to design "immediate-wear clothes" that sold in high-end stores across the country.[10] He used American ginghams, calicos, and a family of harmonized wools called Perennials, designed by Pola Stout for Botany Mills. The coordinated colors harmonized so you could build a dependable wardrobe of jackets, skirts, and coats over years.

American designers were encouraged to draw inspiration from cultural specimens in museums as they had been doing before the war. In this way textile designers demonstrated and disseminated knowledge of world art history. New silk screen-printing allowed innovative printed textile designs to be affordable. Compared to engraved rollers, the screens were less expensive and faster to set up, reducing the financial risk of shorter experimental runs, and allowing larger and freer pattern repeats that were unconfined by the circumference of a metal roller. Marcel Vertès's murals on Fifth Avenue provided the backdrop for a fashion shoot of new abstract screenprints, making cultural links between fashion, textiles, and modern art.[11] These connections were made more explicit in a collaboration between New York's Midtown Galleries and Onondaga Silk Company in the spring of 1947—the gallery approached the mill to print dress fabrics designed by American artists based on their paintings, which were then shown together with the fashions in museums and department stores.

The primary identity of American fashion was in sportwear, with Claire McCardell, Tina Leser, and Bonnie Cashin among its leading innovators. McCardell was quoted in *The New York Times* on March 21, 1943, asserting that "America is developing honest to goodness clothes made only for the ways and habits of American women and the lives they are living." Claire McCardell for Townley fashions were sold at Lord & Taylor, a department store that had consistently promoted American goods since the 1930s. The American look took off postwar, epitomized by McCardell's pared-down cuts for dresses, separates, and swimsuits. Her functional shapes in classic cottons or wool jerseys were flexible for each wearer for years, as their fits were adjustable with clasps, ties, and belts. Fashion historian Valerie Steele has called her "probably the most important American ready-to-wear designer of the twentieth century."[12] McCardell's designs transcended the ins and outs of fashion, with her patented Pop-over dress—originally meant to be "popped over" something nicer while doing housework—long outlasting the war, with versions in production for years. Her legacy continues in the work of designers Donna Karan and Norma Kamali (both still working).

Postwar and Dior's New Look Revolution

Between 1945 and 1947 most countries were still operating under wartime restrictions and economic strain. The 1948 Marshall Plan provided American aid to Europe for recovery efforts and to re-establish trade. When Christian Dior launched his spring 1947 New Look in Paris, with its soft shoulders, cinched-in waists, full hips, and long skirts, he started a fashion revolution and reasserted Paris couture's design supremacy. He became the most influential designer of the day and throughout the 1950s.

The New Look sent shock waves across the industry. It required a complete reassessment of costs for design, patterns, materials, and labor. Women's wardrobes were outdated. It was impossible to make a wide New Look skirt from a slim one, or to wear a knee-length old-look coat over a long New Look dress. It took time for fashion to adjust, but it did, at the same time that many women moved out of the workplace and back into the home.

The 1950s saw waves of positive progress after the war. French couture entered a golden age. In England the long-term effect of the Utility Scheme raised the caliber of clothing, which gave British designers a reputation for quality. Italy recovered and began to be an important fashion center. There was a new pride in American fashion, from high-end custom and ready-to-wear to cheaper, democratic design. American designers grew in local

and international stature, gaining a reputation for fun, elegant, uncluttered, affordable, and workable fashion that moved with women, in and out of the home, in and out of the car, and from day to evening. Fashion continued to be a vital force in the postwar economic boom.

Alexandra Palmer, Chevalier, L'Ordre des Palmes académiques, is an award-winning curator, author, and sessional lecturer at the University of Toronto specializing in the history and sustainability of textiles and fashion.

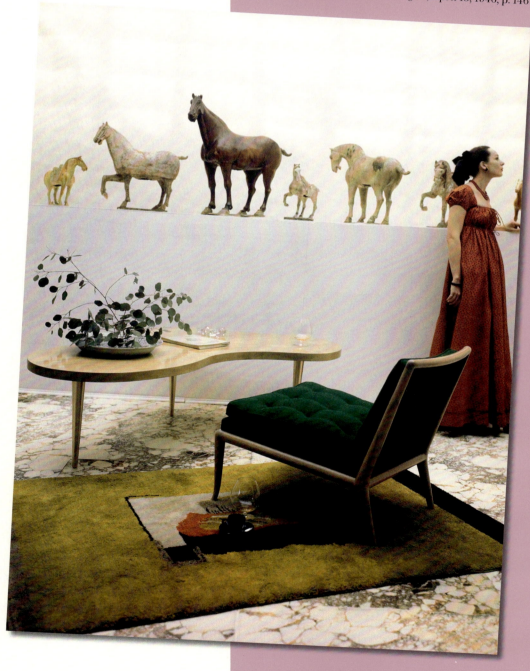

Quintessential American designer Claire McCardell blended "American with Empire" in her summer 1946 high-waisted, short-sleeve dress—made in a Bates Mill reproduction of a 19th-century American printed cotton. It was for sale at Lord & Taylor for $30. From "Notes on Decoration," *Vogue*, April 15, 1946, p. 146

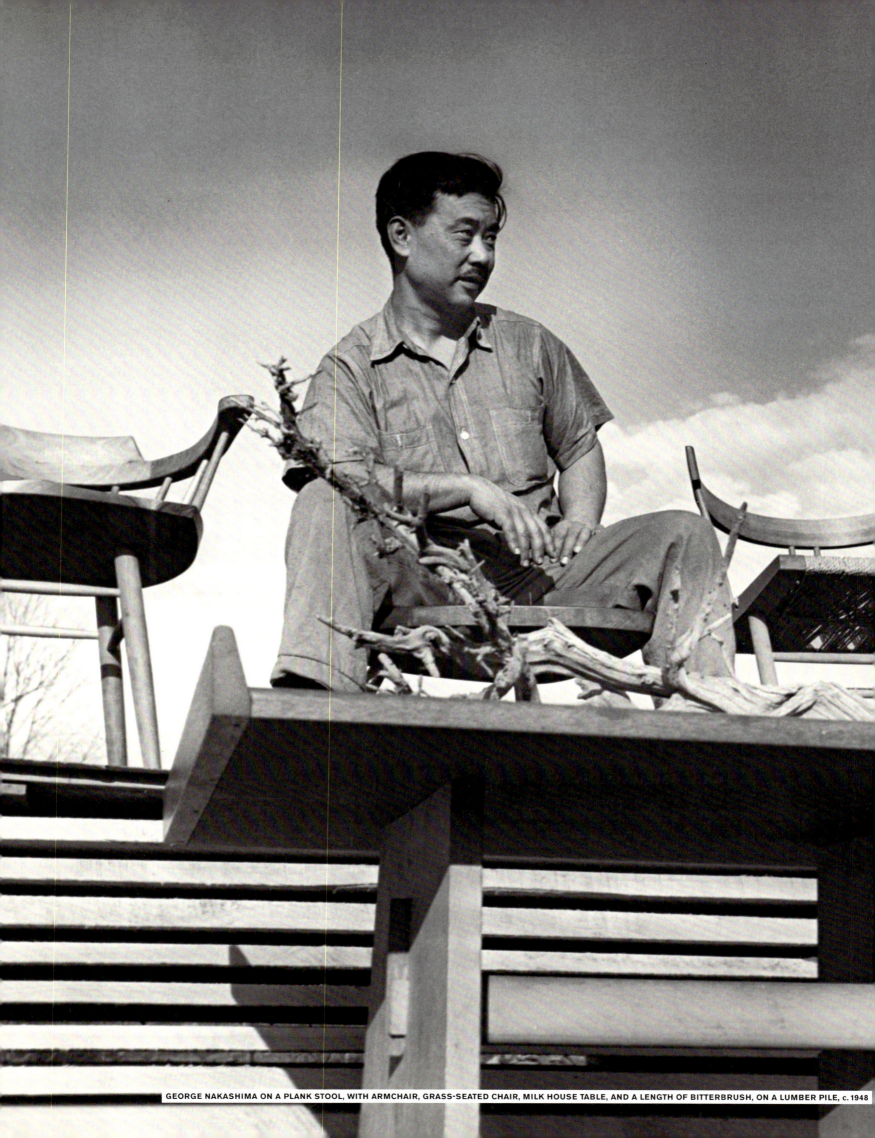

GEORGE NAKASHIMA ON A PLANK STOOL, WITH ARMCHAIR, GRASS-SEATED CHAIR, MILK HOUSE TABLE, AND A LENGTH OF BITTERBRUSH, ON A LUMBER PILE, c. 1948

In response to the Japanese attack on Pearl Harbor on December 3, 1941, President Roosevelt signed Executive Order 9066 on February 19, 1942, authorizing the removal of Japanese citizens and immigrants from their homes on the West Coast and their internment in camps set up in remote areas.[1] The architect and designer George Nakashima, along with his wife, infant daughter, and more than thirteen thousand others, was forcibly interned at Minidoka War Relocation Center in Jerome County, Idaho.[2] Having recently turned to furniture design and woodworking after studying architecture,[3] Nakashima apprenticed himself to fellow detainee Gentaro Kenneth Hikogawa, a Japanese *daiku* (master carpenter) from whom he learned a reverence for trees and the use of Japanese hand tools and traditional methods of joinery. In 1943, with the aid of the American Friends Service Committee's program for Japanese American resettlement, Nakashima and his family were relocated to New Hope, Pennsylvania, to live and work on the architect Antonin Raymond's farm.[4]

Nakashima set up a makeshift studio on the farm to establish himself as a studio furniture designer and began a line of furniture forms. In a February 1944 letter to René d'Harnoncourt, then director of the Department of Manual Industries at the Museum of Modern Art in New York, he introduced himself: "For the past three years I have been engaged in the design and construction of furniture. I feel that there is a place for a better correlation of good sound wood design and modern requirements. In a way too, a synthesis between the fine tradition of east Asiatic workmanship and modern American taste."[5] In the spring, d'Harnoncourt commissioned a design for a coffee table, which he placed in his office. Nakashima explained his use of a "fence" at one end of the table as resulting from the walnut plank's tendency to warp and shrink, and the heavier splayed legs as avoiding a "spindly quality" to support his selection of a "heavier" tabletop.[6] The table is a significant example of the first phase of Nakashima's practice, which was primarily client-driven custom work. These commissions helped him establish important connections and a permanent studio. Later that year, d'Harnoncourt ordered a chair from his studio, a work completed in 1946.[7] This grass-seated chair, a form for

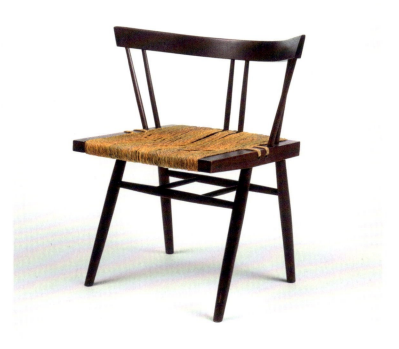

GRASS-SEATED CHAIR, 1946

COFFEE TABLE FOR RENÉ D'HARNONCOURT, 1944

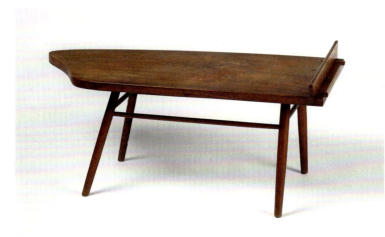

which Nakashima would become well known, is made of solid walnut and evolved from earlier versions made in 1934, 1939, and 1941.[8] The first of its kind, the chair is the embodiment of Nakashima's determination to make furniture that successfully melded East Asian workmanship with modern taste. By contrast, a straight-backed chair designed that same year, also made of walnut and with a steam-bent shaped top rail but with a poplar seat, is the earliest example of his standardized seating designs (opposite, left).[9] It shows his early experimentation with creating modern seating inspired by traditional vernacular forms, in this case the eighteenth-century Windsor chair.

These two early examples of seating furniture by Nakashima mirror a tension within his work that points to race and identity. Nakashima declared that he was a "citizen of the world" and transcended national or racial boundaries, yet he dared to embrace a Japanese aesthetic after experiencing deep injustice and discrimination because of his race and ethnicity.[10] He also celebrated the spirit of centuries-old American vernacular furniture, incorporating their designs into his work. Although he claimed that the wounds of his internment experience had "healed over and left no scars,"[11] his combination of American and Japanese aesthetics reflects the construction of his own national identity and became the singular principle of his work.

Elisabeth Agro is the Nancy M. McNeil Curator of Modern and Contemporary Craft and Decorative Arts at the Philadelphia Museum of Art.

GEORGE NAKASHIMA

Synthesis and Identity

HOLLYWOOD
in the 1940s

From the Great Depression through World War II and into the postwar boom, the film industry witnessed political turmoil, box office riches, monopoly-busting Feds, the birth of film noir, and a renaissance for women's pictures. Steven Rea considers a pivotal era in the history of motion pictures.

Dooley Wilson, Humphrey Bogart, and Ingrid Bergman in a scene from *Casablanca* (1942)

The American Film Institute's list of the 100 Greatest Films of All Time is topped by two from the early 1940s: *Citizen Kane*, at no. 1, and *Casablanca*, at no. 2 (or no. 3, depending on which AFI list you're looking at).

Released in 1941, *Citizen Kane* is Orson Welles's electrifying chronicle of heady ascension and delirious downfall, using the real-life narrative of news emperor William Randolph Hearst as the template, and deploying a behind-the-camera crew (headed by cinematographer Gregg Toland) that upended the way screen stories were told. This film's breathtaking technical dexterity is rivaled only by Welles's uncanny portrait of the imperious, impulsive, self-destructive Charles Foster Kane, and by the performers encircling him: Joseph Cotten, Dorothy Comingore, Everett Sloane, et al. (Rosebud, anyone?).

The 1942 classic *Casablanca* finds star-crossed lovers in a Moroccan port city during the German occupation. Humphrey Bogart and Ingrid Bergman bring slow-burning intensity to a sweeping tale that is as much about smoky exoticism and their characters' thwarted romance as it is about American isolationism, personal sacrifice, self-interest, and cynicism ceding to a just cause: stymieing the Nazis, looking out for freedom, making friends on that fog-shrouded airport tarmac. *Casablanca* could well hold the record for the highest number of famous quotes from a given film, any film, in any decade. *"We'll always have Paris." "Round up the usual suspects." "Here's looking at you, kid." "Of all the gin joints in all the towns in all the world, she walks into mine." "Louis, I think this is the beginning of a beautiful friendship."* And that oft-misquoted line, *"Play it, Sam"* (there is no "again").

Before Pearl Harbor

At the beginning of the 1940s, before the Japanese bombing of Pearl Harbor on December 7, 1941, Hollywood was in a state of collective apprehension over events in Europe. There was a sense of uncertainty about the films people wanted to see. *Gone with the Wind*, released in late 1939, was raking in millions well into the new year. The heads of the eight major studios—Columbia, MGM, Paramount, RKO, 20th Century Fox, United Artists, Universal, and Warner Bros.—looked at David O. Selznick's independently produced mega-hit and weren't exactly sure how to proceed: more high-budget, grand-scale fare in the vein of *GWTW* or business as usual? But business as usual—crime films, romances, screwball larks, middle-tier talent in middle-tier titles—was down. Box office numbers in January 1940 were considerably lower than the same month in 1939, and if you took away *Gone with the Wind*'s grosses, which accounted for half of Hollywood's net profits in 1940, the numbers were even more dire.

Dire, too, were the soundings from Europe. In September 1939 the Nazis stormed into Poland, prompting England and France to declare war on Germany. Alfred Hitchcock's *Foreign Correspondent*, released in the summer of 1940 and starring Joel McCrea as a wise-guy New York newsman dispatched to Europe, turned out to be eerily prescient. McCrea's Huntley Haverstock (a grandiose nom de byline for a no-nonsense crime reporter) stumbles on an assassination plot that would lead to all-out war. At the end of the film, London is being bombed by the Luftwaffe and McCrea is on the radio. "Hello America," he says, telling his broadcast listeners that "a part of the world [is] being blown to pieces." Abandon neutrality, he urges. America is Europe's last hope. One week after *Foreign Correspondent*'s stateside release, London was in fact being bombed by the Luftwaffe.

Despite calls for neutrality from isolationists in and out of Congress, and despite the certainty that lucrative foreign film markets would be lost

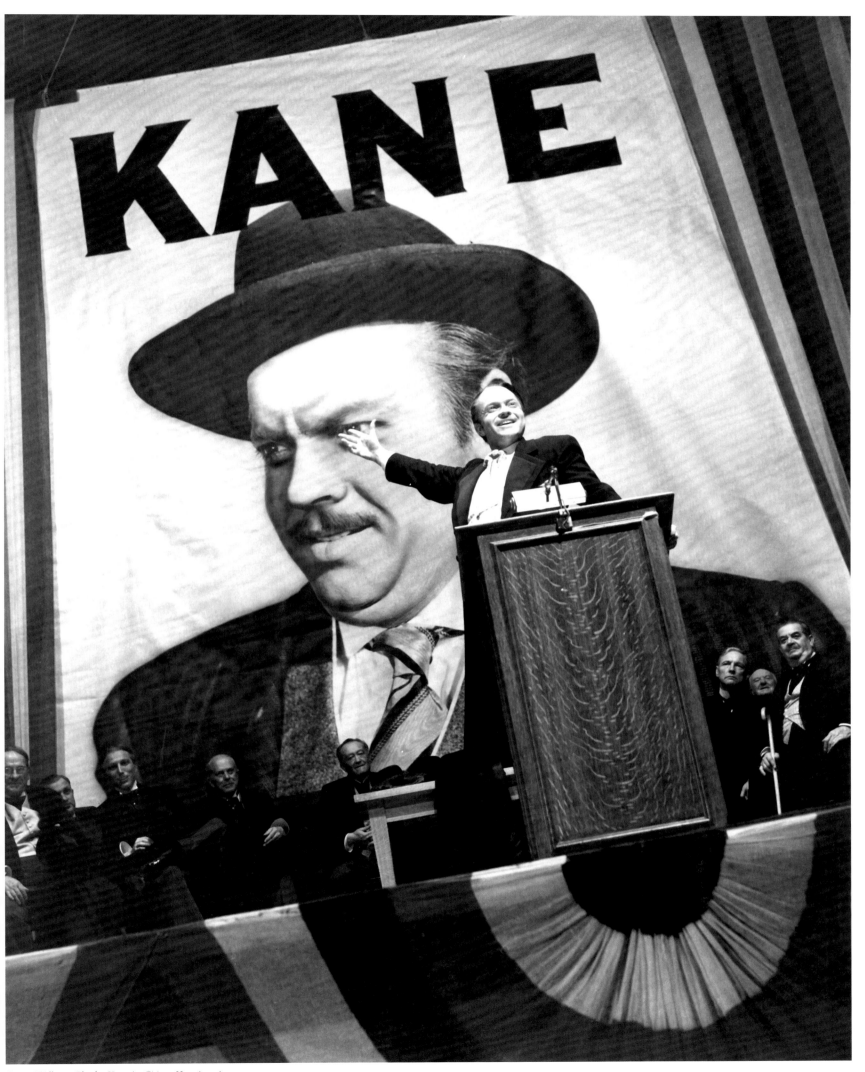

Orson Welles as Charles Kane in *Citizen Kane* (1941)

if the United States entered the war, a clutch of other anti-Nazi, anti-fascist films made it to theaters preceding President Franklin D. Roosevelt's declaration of war. Warner Bros. released *Confessions of a Nazi Spy* in 1939, and studio chief Jack Warner was already raising funds for the Hollywood Anti-Nazi League. *The Mortal Storm* (James Stewart as a "non-Aryan" in Germany when Hitler is named chancellor), *Escape* (Robert Taylor searching for his mother in a German concentration camp), and *The Man I Married* (Joan Bennett as a naive Yank visiting Nazi Germany with her husband) all came out in 1940. Even the Three Stooges got into the act with their short *You Nazty Spy!* Fritz Lang, who left Germany for Southern California in 1933, directed *Man Hunt* (1941), a political thriller designed to persuade Americans that maintaining neutrality would be cataclysmic. And then there's Charlie Chaplin's first talkie (and one of his biggest hits): the pointed Hitler parody *The Great Dictator* (1940).

Hollywood Mobilizes

Following the Pearl Harbor attack and President Roosevelt's declaration of war on the Axis nations, Hollywood went all in. FDR appointed a government liaison to work with studio heads, the Treasury Department coordinated with studios and their stars to campaign for government war bonds, and the Office of War Information was formed to oversee messages going out over the radio, in newspapers, and in the movies. The stars enlisted: James Stewart flew twenty missions over Germany as a bomber pilot; William Holden joined the army; Tyrone Power joined the marines; Robert Montgomery joined the navy and ended up commanding a US destroyer during D-Day.

As machinists and assembly-line workers, gas station attendants and diner cooks signed up to fight overseas, American women stepped into a job market that had historically been dominated by men. And Hollywood was quick to champion the gender shift: Paramount's 1942 musical *Priorities on Parade* finds dance band trouper Ann Miller going to work in a munitions factory. Republic Pictures celebrated the changeover with 1944's comic musical *Rosie the Riveter,* with Jane Frazee starring as a defense plant worker. On the studios' backlots and sound stages, women were trained to work in lighting, camera, sound, and editorial. But one position didn't become an option for women during this time: film director. Dorothy Arzner, who came up through the Silent Era and directed pictures with Claudette Colbert and Katharine Hepburn in the 1930s, was the notable exception, capping her filmmaking career with the 1943 war drama *First Comes Courage*, starring actress Merle Oberon as a Norwegian resistance fighter.

In Hollywood, Bette Davis was instrumental in opening the Hollywood Canteen, where anyone in military uniform was able to dine and dance before going off to war. Marlene Dietrich, Rita Hayworth, Gene Tierney, and a fleet of other female stars served food, signed autographs, and danced with the men. Dorothy Lamour, Lana Turner, and Carole Lombard sold millions of dollars in government war bonds. Hedy Lamarr, the Austrian siren (and coinventor of the frequency-hopping spread spectrum), offered to kiss any man who would buy $25,000 worth of bonds.

Barbara Stanwyck and Fred MacMurray in *Double Indemnity* (1944)

Poster for *Out of the Past* (1947)

Postwar Anxiety

As soldiers, sailors, and airmen returned to the States following the Allied victories in Europe and the Pacific, women were expected to return to the home. That conflict can be seen as the subtext of a number of films in the postwar era. In Otto Preminger's *Daisy Kenyon* (1947), a New York commercial artist (Joan Crawford) in an affair with an unhappily married lawyer (Dana Andrews) begins a courtship with a shell-shocked war veteran (Henry Fonda). If *Daisy Kenyon* is a romantic-triangle melodrama with a noirish bent, *The Strange Love of Martha Ivers*, released in the months after VE-Day and VJ-Day, is full-on noir. Directed by Lewis Milestone, Barbara Stanwyck stars in the title role as the head of a thriving Pennsylvania factory. Her employees number in the thousands, and she wields power in political circles. But of course there's a dark secret in her past, shared by her doting husband (Kirk Douglas, in his first screen performance). Enter an itinerant war veteran, an old friend (Van Heflin). Trouble ensues.

"Troubled" is the operative word in a number of movies that tracked American troops coming home, trying to reassimilate into society, return to the old job, the family, the wife. No film captured that struggle with more success (seven Oscars, no. 1 at the box office) than *The Best Years of Our Lives* (1946), William Wyler's nearly three-hour drama about three returning veterans. Fredric March is the infantry sergeant who can't settle back into his job as vice president of a bank. Dana Andrews is an air force captain who comes home to find a wife (Virginia Mayo) he no longer loves, and vice versa. And Harold Russell—a real-life veteran who lost both his hands to defective explosives—is a navy machinist trying to adjust to a physically challenged life, worried that his high school sweetheart (Cathy O'Donnell) won't be able to cope with a man who has mechanical hooks at the ends of his arms.

Although PTSD (post-traumatic stress disorder) was not labeled as such until 1980, thousands of veterans returned from the horrors of World War II, the liberation of the Nazi concentration camps, and the bombings of Hiroshima and Nagasaki haunted, shaken, shell-shocked. If America in these postwar years was a place where suburbia bloomed, where the GI Bill allowed new avenues to education, employment, and home ownership, where the economy was robust, it was also a place where disillusionment ran deep.

Film Noir

That undercurrent of cynicism and anomie courses through what French critics would later label *film noir*. Hollywood crime dramas and thrillers steeped in moral ambiguity, with men and women driven by greed, lust, revenge, and a sense of lonely doom. A few key films of this golden age of noir (though "golden" seems altogether the wrong word to describe a genre shot through with dark, shadowy imagery) are also major films in the history of cinema: Howard Hawks's *The Big Sleep* (1946), adapted from the Raymond Chandler novel; Billy Wilder's *Double Indemnity* (1944), from a James M. Cain book, with a screenplay by Wilder and Chandler; and Jacques Tourneur's *Out of the Past* (1947), with a hard-bitten Robert Mitchum on the snake-winding trail of an impossibly beautiful and murderous femme fatale, played by Jane Greer.

Many notable directors of these moody, menace-limned melodramas were émigrés from Europe, having left Austria, Germany, or France in the 1930s, as Hitler rose to power and anti-Semitism reigned, to find a new home, and new employ, in Hollywood. They brought with them a visual sensibility and style owing much to German Expressionism: agitating angles, high-contrast black-and-white palettes, crosshatched lighting. Michael Curtiz, who directed *Casablanca* and *Mildred Pierce* (1945), fled Hungary to become one of Jack Warner's go-to guys on the Burbank backlot. Fritz Lang left Germany, and made *The Woman in the Window* for RKO (1944) and *Scarlet Street* for Universal (1945). Otto Preminger, an Austrian stage and screen director, was hired by 20th Century Fox, where he brought his meticulous craft to the eerie crime piece *Laura* (1944), and then *Fallen Angel* (1945) and *Whirlpool* (1950).

Women's Pictures

Some of the most notable films of the 1940s—notable for both their box office numbers and their critical success—were films about, and aimed primarily at, women. In the iconic melodrama *Now, Voyager* (1942), Bette Davis plays an unhappy spinster who gets out from under her mother's abusive control to become a strong and striking independent woman. In *Gaslight* (1944) Ingrid Bergman's character is slowly steered toward madness by her husband (played by Charles Boyer).

Two romantic dramas released in 1949 both brought home Oscars. In *A Letter to Three Wives*, best friends played by Jeanne Crain, Linda Darnell, and Ann Sothern receive a missive from another friend announcing that she is running away with one of their husbands, but they aren't told which husband. *The Heiress* stars Olivia de Havilland as a cloistered woman whose courtship by a handsome interloper (Montgomery Clift in an early Hollywood role) raises her abusive father's suspicions. These films, and many others in this thriving genre, addressed issues of infidelity, vulnerability, manipulation (make that man-ipulation), resilience, desire, and blossoming self-knowledge.

Black Cinema

Hattie McDaniel was the first African American to win an Oscar when she brought home the Best Supporting Actress award for her role in *Gone with the Wind*. At this time Black actors continued to be typecast as servants, busboys, train conductors, cooks. In 1942 representatives from the Los Angeles chapter of the National Association for the Advancement of Colored People met with studio executives, lobbying for more substantive parts for Black actors, for roles that weren't patterned on traditional, servile stereotypes. Two major-studio, all-Black films were released in 1943: *Cabin in the Sky*, adapted from the hit Broadway musical, with Rex Ingram and Ethel Waters reprising their roles from the stage production and singer/actress Lena Horne in her screen debut. That summer, 20th Century Fox opened another all-Black musical, also with Lena Horne, the rollicking *Stormy Weather*, with a shot-on-one-take song and (tap)dance number from the Nicholas Brothers and Cab Calloway that stands as one of the exhilarating high points in the history of movie musicals.

Independent Black cinema produced a variety of films in the 1940s, including a number of low-budget "race films" written and directed by Spencer Williams. These all-Black productions were aimed almost exclusively at audiences in segregated theaters in the South. Williams's most successful titles include *The Blood of Jesus* (1941; "A Mighty Epic of Modern Morals!" was its tagline) and *Go Down, Death!* (1944). Oscar Micheaux, who wrote and directed shorts and features throughout the Silent Era and into the 1930s, released his Harlem-set crime drama *The Notorious Elinor Lee* in 1940. His final feature, *The Betrayal*, was released in 1948. Billed as "The Greatest Negro Photo-Play of All Time," *The Betrayal* was a critical and financial disaster. Micheaux would not make another film.

In 1943 filmmaker Frank Capra, who had joined the army and made the *Why We Fight* series for the US Department of War, oversaw production of *The Negro Soldier*. Directed by Stuart Heisler, *The Negro Soldier* offers a quasi-documentary overview of Black achievement in various professions and Black bravery in combat. Initially made exclusively for Black recruits, the film was deemed so successful in countering racial stereotypes that it was shown widely in army recruitment and training facilities around the country.

The Writer/Director

Preston Sturges, a young playwright from New York who was fed up with the way directors were mangling his stories, struck a deal to sell one of his scripts to Paramount for a hefty ten dollars, on the condition that he would be able to direct the film himself. That film was *The Great McGinty*—a fast-talking comic fable of political corruption that follows a wily street bum all the way to the governor's mansion. Starring Brian

Poster for *Stormy Weather* (1943)

Actress Hedy Lamarr, coinventor of the frequency hopping device, hopping a fence in a publicity photo, c. 1940

Donlevy, the film opened in the summer of 1940 and was a modest hit. It won Sturges the very first Oscar in the Best Original Screenplay category. More significantly, it won him the clout to keep directing. Over the next five years, as war raged around the world, Sturges would turn out a flight of freewheeling and ingenious comedy gems: *Christmas in July* (also 1940), in which a cash-strapped couple (Dick Powell and Ellen Drew) believe they've struck it rich, followed by *The Lady Eve*, with Barbara Stanwyck as a con artist seductress and Henry Fonda as her lovestruck sap, and *Sullivan's Travels*, a road movie/love story/Hollywood send-up/post-Depression social commentary, with Joel McCrea and Veronica Lake (both 1941). The ants-in-the-pants antic romp *The Palm Beach Story*, with McCrea as a financially strapped inventor and Claudette Colbert as his dispirited spouse, followed in 1942. *The Miracle of Morgan's Creek* and *Hail the Conquering Hero*, both toying with World War II themes in screwball, scandalous fashion, and both released in 1944, rounded out Sturges's remarkable run.

Although a clutch of A-list filmmakers had previously been given the nod to shoot their own stories (notably D. W. Griffith and Frank Capra), Sturges is considered Hollywood's first true writer-director, paving the way for a new breed of auteur talents. And Sturges's legacy has rippled through the decades: the Coen Brothers' *O Brother, Where Art Thou?* (2000) owes not only its title to Sturges (taken from *Sullivan's Travels*)—its whole Depression-era take on the *Odyssey* radiates with Sturges panache. Wes Anderson, Peter Bogdanovich, Pixar's John Lasseter, and John Hughes have all cited Sturges as a key influence and inspiration.

Animation

The 1940s also saw the Walt Disney Studios' transformation into an innovative animation powerhouse. If *Snow White and the Seven Dwarfs* dazzled moviegoers (and traumatized more than a few kids) on its release in 1937, the quartet of Technicolor cartoon features that followed wowed audiences in altogether new ways. Animation had been around since the earliest days of cinema, of course, but what Disney's storytellers came up with in the 1940s was something else again: *Pinocchio* (1940), adapted from the Carlo Collodi fairy tale, literally brings a wooden doll to life. Dark, delightful, full of technical innovations and memorable songs, *Pinocchio* captured and conveyed a world—or worlds—that live-action filmmakers of the day could only dream of. For *Fantasia* (1940), Disney collaborated with conductor Leopold Stokowski and the Philadelphia Orchestra for a series of animated suites: Mickey Mouse's "Sorcerer's Apprentice" segment, set to the music of Paul Dukas; a comic menagerie ballet set to a score by Ponchielli; plus vibrant visualizations of compositions by Beethoven, Mussorgsky, Schubert, and Stravinsky. *Dumbo* (1941), neither as creatively ambitious nor as stylistically cutting-edge as the three features before it, turned out to be Disney's most profitable release of the entire decade. *Bambi* (1942) tracks a white-tailed deer and his forest friends through kid-friendly adventures, but also through the natural world's cycles of birth and death. An inspiring tearjerker.

Ubiquitous Bogie

If one actor can be singled out as emblematic of the decade—tough, taciturn, a hero, an antihero, a go-his-own-way American—that actor would be Humphrey Bogart. *The Maltese Falcon* (1941), with Bogart as Dashiell Hammett's San Francisco shamus Sam Spade, made him a star. A year later, *Casablanca* clinched the deal. Four films with leading lady Lauren Bacall didn't hurt any (*To Have and Have Not*, *The Big Sleep*, *Dark Passage*, and *Key Largo*), and 1948's there's-gold-in-them-hills box office hit (and Oscar winner) *The Treasure of the Sierra Madre* cemented his place in forties filmdom. In all, Bogie had thirty credits between 1940 and 1949. Ubiquitous, omnipresent, pretty much bogarting the screen.

Tensions in the Industry

The 1940s also saw major changes to the film industry, the seeds of which were planted in the preceding decade. To prevent rigid government oversight of the industry, the studio heads, in 1934, collectively established the Motion Picture Association and its Motion Picture Production Code (more commonly known as the Hays Code), laying out a set of self-governing, self-censoring guidelines. No more semi-naked chorines, no more frisky depictions of gangster's molls, no more crooks getting away with, well, murder. Through the war years that status quo was maintained—the studios and government had more pressing matters to address. But come September 2, 1945, when the war ended with Japan's surrender, tensions between Hollywood and Capitol Hill ratcheted up again, on two fronts.

As early as 1938, there had been grumblings from members of Congress that Hollywood was crawling with Communists, from the labor unions to the talent guilds to the screenwriters. Texas congressman Martin Dies, calling Hollywood "a hotbed of Communism," formed the House Un-American Activities Committee (HUAC). Now, postwar, those charges were renewed. In 1947, after the committee had been made permanent, its new chair called MGM's Louis B. Mayer and Warner Bros.' Jack Warner to Washington to testify about specific films produced and released during the war that were deemed pro-Stalinist or pro-Soviet, among them *Mission to Moscow* (1943) and *Song of Russia* (1944). Following the 1947 hearings, ten screenwriters and directors—including Edward Dmytryk, who would receive a Best Director Oscar nomination for that year's *Crossfire*, and the prolific screenwriter Dalton Trumbo—were cited with contempt of Congress for refusing to cooperate with the committee. They were subsequently blacklisted by the studio heads. (See the excellent 2007 documentary *Trumbo*.)

While the HUAC hearings cast a pall over Hollywood, the Department of Justice's efforts to break up the studios' monopolies on the distribution and exhibition of their product loomed large over the industry. An original suit, *United States v. Paramount Pictures, Inc.*, filed in 1938 by the department's antitrust division, charged that the eight major studios were essentially conspiring to monopolize the distribution of their films through their trade association, the Motion Picture Producers and Distributors of America. Additionally, five of the major production studios dominated distribution by owning chains of movie theaters—mostly first-run theaters in the country's largest metropolitan areas—elbowing out the small, independent theaters.

Attorneys for the studios challenged the Justice Department at every turn. Through most of the war there was a concept decree, an arbitration board, a certain status quo. But postwar, appeal followed appeal, delay followed delay, until, in 1948, *United States v. Paramount Pictures, Inc.* reached the Supreme Court. In a historic 7-to-1 decision, the justices issued what came to be known as the Paramount Decree, preventing film production companies from owning film exhibition companies. The landmark decision essentially shattered the studios' decades-long business model. More independently owned theaters and smaller chains, along with art house and repertory theaters, sprang up in the years that followed. The old business model, and the old moguls' dominance, were gone.

Steven Rea is the author of the archival photography books The Hollywood Book Club, Hollywood Cafe, *and* Hollywood Rides a Bike. *For many years he was the film critic at* The Philadelphia Inquirer.

Joel McCrea and Veronica Lake taking a break during the filming of the comedy *Sullivan's Travels* (1941)

JACKSON POLLOCK, *MALE AND FEMALE*, 1942–43

LEE KRASNER, *COMPOSITION*, 1949

GENESIS

Jackson Pollock and Lee Krasner

For Jackson Pollock and Lee Krasner, the 1940s represented a critically experimental and generative period. Each worked in a distinctive style, but their evolution as artists and their resulting reputations as pivotal figures in the movement that came to be known as Abstract Expressionism are closely linked.

Traveling in the same New York circles, Krasner and Pollock crossed paths in 1936 but had their first proper meeting shortly before their work was exhibited in *French and American Painting* at McMillen Gallery in 1942.[1] They married in 1945 and bought a house in East Hampton, Long Island, now a historic landmark that bears their names. Professionally, they grappled with similar art-world challenges—what to do with the legacy of Cubism and other modernist trends, how to grapple with the most compelling aspects of Surrealism—seeking their individual artistic voices while supporting one another in their respective careers.

Pollock's *Male and Female* is a seminal work that shows him wrestling with figuration and abstraction early in the decade. On the left, a curvy form atop triangular feet implies a female body. Its long eyelashes frame eyes painted in yellow and red on black. On the right, a black rectilinear form adorned with mysterious arithmetic seems to represent the male body, with the center of the composition suggesting a fusion of genders. Around the composition, explosive bursts of paint foreshadow the drip technique for which Pollock became famous later in the decade.

Pollock included *Male and Female* in his first solo exhibition, at Peggy Guggenheim's gallery Art of This Century in 1943. Guggenheim's patronage was pivotal. In addition to showing Pollock's and Krasner's work, she provided Pollock with a monthly stipend and lent the couple $2,000 as a down payment for their Long Island home.

In 1946 the couple moved the barn on the property to improve their view of the salt marshes and converted the structure into Pollock's studio. Krasner took over as her workplace the small bedroom he had used until then. In this second-floor perch she worked on what she called her "Little Image" series from 1946 to 1949, including the painting *Composition*.[2]

By 1949 Pollock had taken to working on the floor, flinging and dripping paint onto canvases or artist boards without touching his brushes to the surface. Krasner also worked horizontally, with her canvas flat on a table, but the foundational layer of *Composition* is all about touch and control. She applied a thick surface of radiant color with stiff brushes, palette knives, and perhaps by squeezing paint directly from the tube. On top of this jewel-toned layer, Krasner poured a labyrinth of white, forming small subdivisions that create a roughly geometric grid. These white lines aren't flung or dripped. Instead, she coaxed the paint into a personal calligraphy that she referred to as hieroglyphs, perhaps reflecting her interest in Surrealist automatism.

The abstraction, mark-making, and allover treatment of the surface that Krasner explored in *Composition* points toward the work for which she became better known in subsequent decades. After Pollock's death in 1956, she took over the barn as her studio and began making larger paintings that included lyrical, sweeping gestures and more open space.

While clearly differentiated in their respective development as artists, Krasner and Pollock had art historical, technical, and thematic overlaps that make consideration of these two works together so compelling.

Jessica Todd Smith is director of Curatorial Affairs, and former Susan Gray Detweiler Curator of American Art, and manager, Center for American Art, at the Philadelphia Museum of Art.

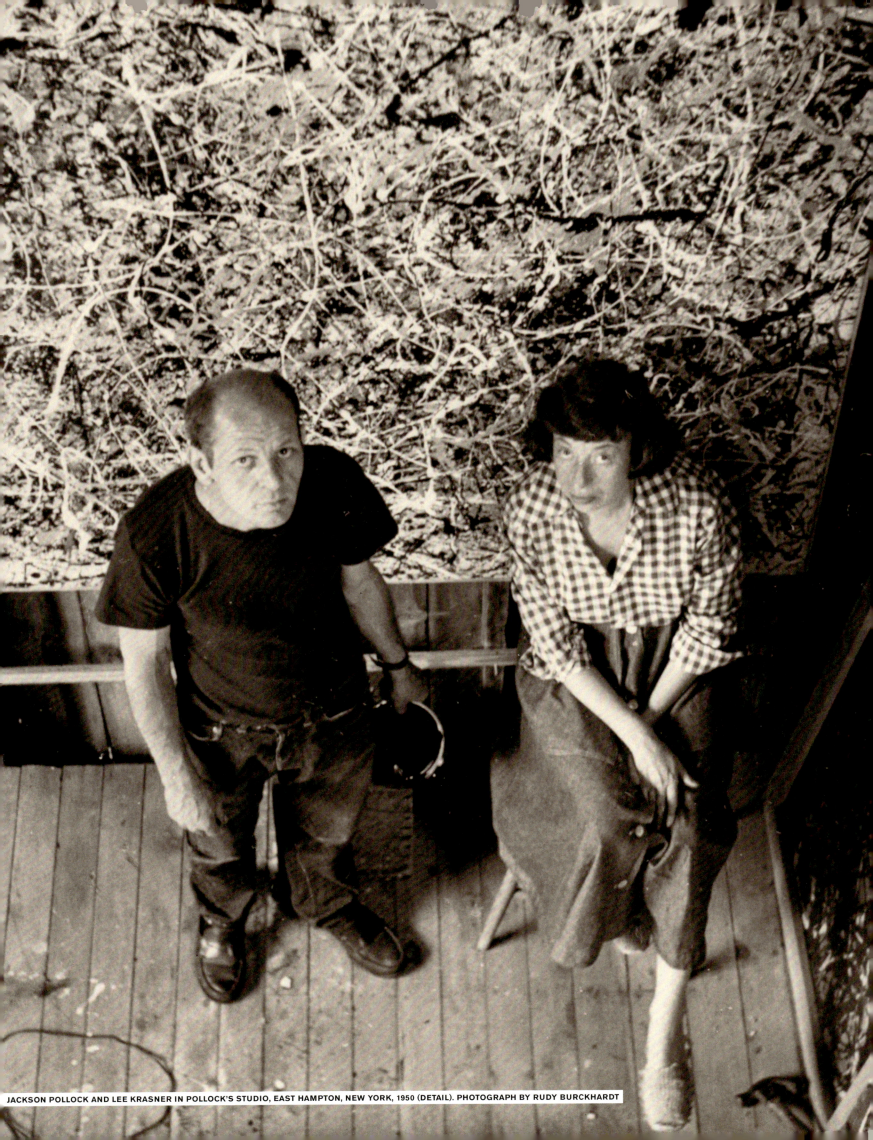

JACKSON POLLOCK AND LEE KRASNER IN POLLOCK'S STUDIO, EAST HAMPTON, NEW YORK, 1950 (DETAIL). PHOTOGRAPH BY RUDY BURCKHARDT

THE ECONOMIES OF WAR

Hugo Gellert's screenprint *Free Man's Duties I*, from his portfolio *Century of the Common Man*, published by the International Workers Order, New York, 1943

From the aftermath of the Great Depression through World War II and the postwar recovery, the people and economies of the United States, Britain, Europe, and Japan were put through the wringer in the 1940s. Nations were gearing up for war, fighting each other, shifting back to a civilian economy at war's end, and rebuilding from the destruction in Europe and Japan. Each country met the rapidly shifting conditions of the decade in its own way. Postwar recovery efforts set the stage for a quarter century of growth.

As the 1940s began, the United States was still feeling lingering effects from the Great Depression and, separated by oceans from the conflicts raging across Europe and Asia, had a minimal military and a tiny defense budget. Britain was better prepared for conflict because it had maintained a robust military to manage its empire. Hitler spent the 1930s rebuilding the German war machine, and that spending brought its economy back to full employment, ending Germany's depression. France, after several wars with Germany, invested heavily in the 1930s in the Maginot Line, modern battlements impervious to air attack and containing underground railways. But these defenses proved useless against the Nazis because they did not extend along the border with Belgium to the English Channel, allowing the Germans to race through Belgium into France in 1940. Italy, too, ended its depression by spending heavily on a military that turned out to be largely ineffective. The Soviet Union was engaged in territorial expansion, having signed a nonaggression pact with Germany in 1939 that established each country's sphere of influence. Japan had gone from three hundred years as a hermit society sealed off from the world to a country engaged in imperialist conquests in Korea and China.

WARTIME

GERMANY

With its invasion of the German-speaking parts of the Czech Republic in 1938 and the invasion of Poland in 1939, Germany was already at war before the decade began. Its military looked invincible, and the military spending that had ended unemployment continued to fuel an increase in factory production until the final years of the war. Germany confiscated whatever it wanted from the countries it conquered, everything from French wine to Romanian oil. Even its art holdings grew through looting.

As the war progressed, Germany experienced increasing setbacks. Its military forces were pushed out of North Africa. Benito Mussolini invaded Greece and had to be bailed out by Nazi forces, which delayed Hitler's push into Russia. This guaranteed that the German military would get bogged down in the Russian winter, resulting in large losses and eventual defeat. The Allied forces repeatedly bombed German cities, including firebombing Hamburg and Dresden, turning factories, infrastructure, and homes into rubble.

FRANCE

The Battle of France began on May 2, 1940, and ended on June 22, 1940, with Germany occupying northern France, along with Belgium, Luxembourg, and the Netherlands. Germany drained the French labor force, conscripting millions of French men to work in the German war industries, essentially as slave labor. The Vichy government, which ran southern France, nationalized French industries and took orders from the Germans on what to produce. Germany seized 20 percent of French food production (half of the meat), even as agricultural production fell by half due to shortages of manpower, fuel, and fertilizer. Food rationing was imposed very early in the war. Under a puppet regime and in response to the shortages of goods, black markets sprang up. Aside from collaborators, day-to-day life for most French citizens was demoralizing and grim. For Jews, it was deadly.

ITALY

In the 1930s, Italian dictator Benito Mussolini nationalized major segments of the economy and fostered industries to support a war machine that meddled ineffectually in the Spanish Civil War from 1936 to 1939. By 1940, when Italy joined the Axis powers to further its territorial plans (most notably in North Africa and the Balkans), his military buildup had ended the residual effects of the depression in Italy. In July 1943 the Allies invaded Sicily and fought a long string of battles up the peninsula against German forces, as the Italian forces had surrendered immediately after the Allied invasion. The combat, along with the associated bombing campaigns, devastated the country, its cultural heritage, and its economy, with its currency falling to a thirtieth of its value by the war's end.

BRITAIN

In wartime Britain life was especially bleak, with the country's very existence in the balance. After the French defeat and the nonaggression pact between Hitler and Stalin, Britain was the only country standing up to Germany until the US entered the war following the Japanese attack on Pearl Harbor on December 7, 1941. An island nation, Britain was heavily dependent on imports, and German submarines were torpedoing large numbers of ships, making wartime shortages even more acute. Civilian goods were strictly rationed. In part because of the destruction from heavy bombing, the British GDP grew by only 15 percent from 1939 to 1945.[1]

Families were separated, as parents sent their children to the countryside to protect them from air raids on the cities. Because the Luftwaffe attacked after dark, those remaining often spent their nights sleeping in subway stations and bomb shelters. Lights were kept off or houses were outfitted with blackout curtains so that the German bombers could not locate their targets at night.

JAPAN

Japan had avoided the worst effects of the Great Depression by turning itself into a military state and feeding off its recently acquired colonies. (The country had annexed Korea in 1910 and Manchuria in 1932 and was expanding further into China.) Although Japan was producing advanced military hardware, its economy was not as diversified as those of Western nations. Eighty percent of its land is mountainous, yet over half the population of 70 million lived in rural areas farming small plots of land. To meet the needs of its military, in 1938 the government began rationing, with rations shrinking each year. Subsistence farmers had to meet quotas on delivering food to the government, leaving very little for the farmers.[2]

In 1944 the United States began strategic bombing raids on mainland Japan. Because Japanese cities were built of wood instead of brick or stone so as to better survive earthquakes, the firebombing raids caused more immediate damage to Japan than the nuclear warheads, and civilians left the cities for the safety of the countryside. The firestorm from just one raid on Tokyo killed an estimated 80,000 to 100,000 people and left one million homeless. The fires were so hot that steel girders melted into twisted sculptural shapes. By the end of the war, people were foraging in the forests for food because the US Navy had cut off all imports of goods.

UNITED STATES

In support of Britain and facing the threat of war, the Roosevelt administration began a military buildup prior to declaring war. In 1939 the US military had 334,473 soldiers; as war preparations accelerated in 1941, the forces grew to 1,801,101 (the nation's first peacetime military draft had been approved in September 1940), peaking by war's end at 12,209,238.[3] Since the outcomes of modern wars are mainly determined by logistics, the US had to rapidly increase production in crucial industries despite a large number of men being removed from the labor force to become soldiers. Women and minorities were hired in their place. Between 1940 and 1945 the number of women in the workforce rose from 12 million to 16.5 million, an almost 40 percent increase. The rise was most striking in manufacturing, increasing from 2.5 million to 5.6 million. By 1943 there were 310,000 women working in aircraft production, 65 percent of that industry's total workforce.[4]

Spending on defense reached a peak in 1945, when it grew to 37 percent of GDP. Production of uniforms, guns, aircraft, ships, and ammunition had to be scaled up. The US shipbuilding industry had collapsed in 1921 and had not recovered by the onset of the 1940s because of excess capacity left over from World War I, the collapse in demand due to the Great Depression, and the decline of international trade resulting from a rise in tariff barriers. In response, President Roosevelt launched his Emergency Shipbuilding Program in January 1941.

Henry Kaiser revolutionized shipbuilding. An industrialist whose company, Kaiser Engineers, built the Hoover, Grand Coulee, and other large western dams, Kaiser introduced assembly-line techniques in his shipyards. By the end of the war his yards were producing freighters, called Liberty Ships, at the rate of one per week. Kaiser regularly held contests to see how fast a ship could be built, and his workers set a record—building one in four days.

Automobile plants converted to producing airplanes, tanks, and transport vehicles. Farm production soared. Clothing manufacturers switched to making uniforms, while fabric for civilian clothing was rationed. Other items rationed for the war effort were rubber, gasoline, fuel oil, and shoes. Food supplies were prioritized for US troops and allies, except for fresh vegetables. Civilians were encouraged to salvage materials such as scrap metal, tires, and paper for the war effort.

The expansion in defense spending was financed by higher taxes and massive budget deficits. The top income tax rate maxed out at 94 percent. Inflation was contained through price controls and rationing. With consumption restricted, people showed their patriotism by buying war bonds with their high level of savings. The one area of the civilian economy that boomed was movies, because making them did not consume large amounts of materials, the industry participated in propaganda efforts, and civilians needed something to do.

TRANSITIONING TO PEACETIME

Each country involved in World War II found itself in a different economic situation at war's end. Except for Pearl Harbor and the Japanese occupation of two small Aleutian Islands, the United States had been spared the physical destruction suffered by its allies. France mostly avoided physical destruction during the German conquest. However, the Allied forces bombed the infrastructure used by the German occupation forces, killing large numbers of French citizens in the process. Britain

Abram Games, a Londoner born to Jewish refugees, became Britain's "Official War Poster Artist" during World War II. Here he urges citizens to grow their own food to avoid importing it by sea.

Schoolchildren in St. Clair, Michigan, collect scrap metal as part of the World War II salvage operation in this photo published by *The Detroit News* on October 16, 1942.

Tokyo residents converting disabled buses to homes for their families, October 2, 1946

A crowd of onlookers gathers on September 27, 1941, to watch as the Liberty Ship *Star of Oregon* is launched into the Columbia River at Henry Kaiser's Oregon Shipbuilding Corporation.

In this British poster from 1943 drivers are urged to slow down to preserve tires. Rubber was needed for military vehicles, boots, gas masks, raincoats, and other items during the war, and was strictly rationed.

This poster by Abram Games, Britain's "Official War Poster Artist," urges troops to focus on cleanliness for their own and fellow soldiers' benefit.

Glenn Grohe's 1942 poster, made for the US Office for Emergency Management, shows a Nazi soldier peering over a wall, reminding citizens to beware of who might be listening.

Military needs and supply disruptions led to the rationing of some foods in the US. This American poster of 1943 stresses the importance of food in the war effort.

had been through the Blitz (the Nazis' sustained bombing offensive), undergoing heavy casualties and major damage to its cities and ports, and incurred huge international debts to pay for its role in the war.

Japan likewise suffered tremendous infrastructure damage and loss of life from the firebombing of cities and the atomic blasts at Hiroshima and Nagasaki on August 6 and 9, 1945. Because of its dependence on imports, the country experienced serious malnutrition by the end of the war. Roughly 100,000 Japanese died in a 1945 famine after the war was over. Italy was heavily damaged by bombing and the ground war, although both sides had agreed to spare Rome. The US and British bombing campaigns essentially leveled Germany's largest cities. However, their indiscriminate bombing of civilian targets was counterproductive because workers employed by the destroyed factories were then freed up to work in German defense plants. On the Eastern Front, the Germans engaged in systematic destruction, including dynamiting the Warsaw palace to below ground level and blowing up the bridges across the Danube in Budapest during rush hour. The Soviets spared little as its armies moved through central Europe and into Germany, committing horrific acts of destruction in Poland and eastern Germany. The USSR suffered the largest losses of all the combatants, with roughly 25 million people killed, and China had the second largest death toll at 20 million. All told, the world suffered between 70 and 80 million deaths as a result of the war, or 3 percent of the world population at that time.

The European powers had lost their empires, and their economies had been shattered. The US was the only nation with the financial resources to support the world economy. It was essential to keep it operating and avoid the kinds of unrest that could lead to new dictators or encourage the expansion of communism. The Soviets were funding Communist parties around the world and engineering revolts in the countries they occupied, putting in place regimes that turned these countries into satellites. One-third of Italians belonged to the Communist Party, and in France the Communists garnered more than a quarter of French votes for the National Assembly in 1947.

All countries affected by the conflict wanted to avoid repeating the mistakes that had led to the war. The Allies worked together to create new institutions that could resolve conflicts through peaceful means. Devaluations of currency had to stop, and new institutions were necessary to manage international debts and trade imbalances. The Bretton Woods agreement in 1944 set up a regime of fixed interest rates and founded the International Monetary Fund (which finances international payments) and the World Bank (which lends to member countries to fund projects that develop their economies). The United Nations was founded in 1945 as a forum to resolve international conflicts, and was designed to address the flaws of the League of Nations (formed in the aftermath of World War I).

GERMANY

After the war governance of Germany was divided into US, British, French, and Soviet sectors, and Berlin was similarly divided. With Joseph Stalin initiating the Cold War, the Western Allies unified the governance of what became West Germany while the Soviet Union retained control over East Germany.

Germany's defeat led to massive population displacements. The Soviets moved eastern portions of East Germany to Poland as compensation for taking eastern parts of Poland for themselves. They also expelled non-Russian populations from the lands they took, and the Poles did the same with the Germans, leading to forced migration. At the same time, Germans in areas annexed by the Nazis were thrown out when the lands were returned. Somewhere between 12 and 14 million refugees arrived in what we now know as Germany, and an estimated 2 million more died in transit. An additional 9 million German prisoners of war would filter back into the country over the next decade.

Violence and fear were widespread. Soviet troops committed an estimated 2 million rapes in East Germany, which had a population at the time of around 18 million. Former slave laborers took retribution against their overseers. Housing was in short supply, and rumors of the Allies confiscating houses for refugees were rampant. High inflation took away 99 percent of the value of any savings.

Initially, the Allies planned to deindustrialize their portion of Germany to the point where it could no longer manufacture armaments on a large scale. About 700 factories were closed, but the Allies soon realized that they needed West Germany actively on their side to counter Soviet aggression, so they stopped trying to shrink German industries. France determined it was better to keep Germany close rather than hold it down, a strategy that led to the formation of the European Coal and Steel Community in 1951, which created a common market for coal, iron, and steel. The Allies then allowed Germany to rebuild its industrial capacity with the latest technologies via aid from the Marshall Plan. The Coal and Steel Community morphed into the Common Market and then the European Union, ending the likelihood of war in Western Europe.

It took West Germany through the 1950s to rebuild its towns and cities, and the reconstruction of destroyed buildings of historical value is ongoing.

In East Germany the Soviets disassembled and moved whole factories to the USSR and extracted reparations. People found the regime and their lives intolerable. They began a migration to West Germany that turned into a flood stopped only with the building of the Berlin Wall. The region was sapped of population, operated under an oppressive regime, and was worn out by the time East and West were reunified in 1990. After huge expenditures on rebuilding, the eastern portion still lags behind the western portion economically.

FRANCE

After the war the French economy grew rapidly. The US wrote off French debts and gave billions through the Marshall Plan. That money was spent on modernizing factories, railroads, and other infrastructure. France went from being a food importer before to the war to becoming a net exporter. The country nationalized several industries right after the war, including railroads, banks, utilities, and automobiles. France, under Charles de Gaulle, began a national planning process that included investments in targeted industries, which led to France becoming a leader in nuclear power and civilian aircraft. Paris regained its position as an internationally renowned center of the fashion industry.

Economically, France entered a period known as the thirty glorious years (*Les Trente Glorieuses*), experiencing economic growth rates higher than all countries except Japan and Spain. This ended in 1973, coinciding with the Arab oil embargo and following US President Richard Nixon's devaluation of the dollar in 1971.

ITALY

With the need to repair damage incurred during the war and the availability of extensive aid, including through the Marshall Plan, Italy grew rapidly, especially in the north. Automobiles, steel, and shipbuilding were major industries. Networks of family businesses in northwest Italy produced high-quality fabrics and supported the fashion industry in Milan. Northern Italy was fully integrated into the other western European economies.

Southern Italy remained a relative backwater despite major reforms, including land reform that broke up the large land holdings of the aristocrats, massive infrastructure spending, and subsidies for building industrial plants. While recent programs have been more successful, centuries of illegitimate government that fostered crime families and political corruption held the region back.

BRITAIN

At the end of the war, Britain still saw itself as a world power. But it was deeply in debt. The pound sterling lost its position as a reserve currency to the dollar and was devalued in 1950. The country lost its colonies in South Asia and Southeast Asia in the late 1940s and the bulk of its African colonies in the 1950s. It could no longer rely on them to purchase British goods or supply raw materials. Although Britain had the second-largest auto industry in the world and was the largest exporter of automobiles in 1947, the industry went into rapid decline as it failed to use advanced manufacturing methods and improve quality. The British aerospace industry produced the famous Spitfire fighter and continued to innovate after the war, including producing the world's first commercial jet airline, the de Havilland Comet. But a string of accidents, including midflight structural failures resulting from metal fatigue, doomed the Comet,[5] ending Britain's role in the commercial aircraft industry. In 1947 the Labor government nationalized many industries, including coal, steel, and the Bank of England, as well as railways, trucking, and canal transportation, turning them into national monopolies. As a result, the industries that depended on world trade lost their ability to compete.

Great Britain squandered the money it received from the Marshall Plan in trying to keep its empire intact, rather than investing in new plants and technologies. Yet its economy grew respectably in the 1950s and 1960s, though not as fast as France's or Germany's. The country had too many legacy industries in decline.

JAPAN

After Japan's defeat, American General Douglas MacArthur was appointed to oversee the rebuilding efforts. His first act was to disband the large conglomerates, known as *zaibatsu*. This policy continued until the Japanese firms were needed to support logistics in the Korean War.

Because Japan had a large population but only 10 percent of the land is suitable for agriculture, the country needed to export products in order to pay for importing food to avoid starvation. Initially, Japan produced shoddy consumer items that did not succeed internationally. The US government provided training to Japanese industries on improving quality and productivity following its methods. Companies such as Toyota adopted these methods and refined them. The Marshall Plan, US training, and the large influx of US dollars for Japan to provide pivotal supplies to the US military during the Korean War led to Japan becoming a world-class center for manufacturing, which continues today.

UNITED STATES

Defying predictions of recession, the US economy continued to boom after the war ended. Unemployment increased by only 1.5 million. Of those, 900,000 were former soldiers getting special federal unemployment compensation. Roughly 2.5 million women exited the labor force, in part due to the baby boom that followed soldiers' homecoming. Around 800,000 veterans took advantage of the GI Bill to go back to school in 1946. Pent-up demand from rationing boosted consumer spending. In 1947 alone 560,000 Veteran Affairs home loans were issued.[6]

Some companies, especially automobile factories, immediately returned to making consumer vehicles. High levels of private investment allowed for the replacement of equipment worn out from overuse during the war and led to new products and factories that kept the consumer boom rolling.

Despite the commonly held view that returning soldiers displaced women from their jobs, about the same number of women were in the labor force in 1950 as in 1945, having filtered back into the workforce. What changed was where they worked. Factory employment of women dropped significantly, while participation in finance, wholesale, retail, trade, and domestic service increased. It was now acceptable for middle-class married women to work, and they preferred offices to factories.

Another major social change was the large migration of Black workers from the rural South to the urban North. The Great Migration began in the 1930s when the Roosevelt administration placed limits on agricultural production and guaranteed farmers high prices to support their incomes. With lower production levels, the need for farm workers decreased and large numbers of Black laborers were pushed out of the rural economy. At the same time, high guaranteed prices made automation affordable. The loss of jobs combined with Jim Crow laws led Black workers and their families to move to Northern cities where factories needed their labor. One-third of African Americans in former slave states moved north between 1930 and 1960, a massive migration.

After the war, Southern states offered large incentives for factories to relocate, gradually taking jobs away from Northern cities. The entry-level factory jobs in the North that provided stepping stones into the middle class started to disappear just as Black workers arrived seeking work.

REFLECTIONS

Because the war had ended the lingering effects of the Great Depression, the question of whether war and its associated military spending was necessary to achieve full employment was frequently debated in the years that followed. In fact, what brought the economies back worldwide was not specifically military spending but national governments' increased spending and the associated deficits; the spending could have been in any area.

So what caused the sustained growth that followed the war, and what led to the eventual slowdown? Classic economic factors contributed to the postwar growth phase: an expanded labor force, a rapid increase in skilled labor, and the expansion of world trade leading to more efficient supply chains. At the same time, the US government ran large surpluses and rapidly reduced its debt, even as it provided financial resources to other countries. High rates of capital investment that rebuilt infrastructure and factories were especially important for the war-damaged economies. In the US, the majority of government budget expenditures were devoted to investments that improved the economy, such as infrastructure and education, rather than consumption. Building the interstate highway system increased the efficiency of moving goods and people, while higher levels of education resulted in a more productive workforce. Postwar goods such as automobiles and televisions were improvements on prewar products, and there were new products that used technologies developed for the military, including jet aircraft and mainframe computers.

With the reconstruction of the economies nearly complete by the early 1970s, high levels of investment in industries and housing were no longer necessary and growth naturally slowed. The rise in oil prices in 1973 extracted large amounts of money from the economies of importing countries, lowering demand for domestic goods. The long-term effect of high oil prices lowered the rate of growth in labor productivity, as companies focused on lowering energy costs. The net effect of the increase in oil prices was a significant decrease in real incomes for workers that took years to recoup and led to long-term stagnation in the stock market.

Economic slowdowns also have to do with maturing businesses and changes in social interactions. As organizations age and become more bureaucratic, they become less creative. Mature organizations are good at efficient production and incremental product improvements but not at inventing radically new products. Fluid social networks and new companies are critical to radical innovation. War and reconstruction in the 1940s layered new, more creative networks on top of old, stable social networks, and the necessity for quick solutions led to rapid innovation. Countries trying to get similar benefits in their economies without wars have yet to succeed, outside the Silicon Valley model.

The 1940s and postwar period had important social consequences. Women demonstrated their competence in the workforce, where their presence became socially acceptable among all classes. This increased their participation in public spheres beyond the home so that today 77 percent of women between the ages of twenty-five and fifty-four work outside the home, and women represent 60 percent of college students in the US. Ethnic, racial, religious, and class divisions were also challenged, as soldiers lived and worked together. The bravery of Black divisions in combat and the successful integration of various groups within the military led President Harry S. Truman to question the continued separation of Black soldiers from other groups, and in July 1948 he desegregated the armed forces.

The momentous events of the 1940s, and the responses of governments and citizens to those events, have shaped and continue to shape the world we live in and the way we live today.

Frederic Murphy is professor emeritus at Fox School of Business and Management, Temple University, Philadelphia. He has published in the areas of energy economics and the computer modeling of markets.

FRAGMENTS OF LOST HISTORIES

Artist and author Edmund de Waal reflects on the tragic events that resulted from the Nazi occupations in Paris and Vienna, sharing his family's own history of living through those atrocities.

ALISON MCDONALD
This project is focused on the 1940s, but I want to start our conversation by going back a few years earlier, to the mid-1930s. Your grandmother and great-uncle are children in Vienna. Their family is affluent and well respected. What do you feel this moment was like for them and other Jewish families in similar positions of influence?

EDMUND DE WAAL
When thinking about my family at this moment, you have to imagine a huge palais in the middle of Vienna full of three generations of possessions—an extraordinary library, pictures on every wall, all the things that anchor you to one place. They were a Jewish family that had very deliberately said they were no longer wandering Jews. They had put their feet down in one particular city, become Viennese, become Austrian citizens, and planned to be there forever. But by the mid-1930s, it's becoming quite clear there are difficult, tumultuous political things going on all around them.

In March 1938 a complete disaster befalls them with the Anschluss, the willing annexation of Austria by its neighbor Germany. Extraordinary as it may seem now, this wasn't a huge, profound shock to them because they never contemplated leaving their home. I think that's a very powerful thing to reflect on. If your home and your identity are connected in such a profound way, having that torn up is almost impossible to imagine. They're living their lives the way any of us would. They're investing in a place, in their home, in their future, and in their children. The murderous, deceitful events that would occur a short time later were inconceivable.

In the mid-1930s, how could you possibly anticipate that your neighbors, whom you've known for decades—the people whose children have gone to the same schools as your children, whom you've shared social spaces with, the cafés, the restaurants, the theaters—are the people who are going to dispossess you, are going to walk inside your home, threaten you, assault you, loot you, deport you.

AM You recently wrote *Letters to Camondo*, which is about Moïse de Camondo, a wealthy art collector in Paris who was a neighbor of your ancestor Charles Ephrussi. You make the writing so personal by connecting with him through a series of letters, almost as though you're writing to a friend. The reader feels an intimate connection with him and his family. There's a passage at the end of the book that is very powerful because you pull back from the personal and instead recount, as a factual timeline, the series of atrocities happening to the Jewish population in France: "On 27 September [1940] the Germans require a census of all Jews in the Occupied Zone." "On 3 October 1940 . . . Jews are excluded from the army, the press and all government positions." "Between 20 and 25 August 1941, 4,232 Jewish men are rounded up [and] taken to an internment camp in the north-eastern suburb of Drancy." "On 7 February 1942 Jews are forbidden to change their residence or be out at night." "On 27 March 1942 the first convoy of Jews leaves Drancy for Auschwitz." Those are extremely dark and difficult events. How do you balance your writing to make the reader feel familiar and close to that family and then step back to give a different perspective on the widespread horror that must've been felt during that time?

EDW To be honest, it's really hard. My typical approach to writing is to begin with an object in the hand—a personal object, a photograph, a letter—because I want to begin with real intimacy, and to share a palpable, real, visceral, and intense kind of present so that all distance is erased. I want people to walk with me, pick things up, and be there when the letter is opened. All those things are really important to me.

So, in dealing with the events of the early 1940s in Paris, I wanted to present them in a very measured, non-emotive way, almost like drawing a camera back from the intimate moment—back, and back, and back, so that you can see what happens day to day: On this day, Jews are no longer allowed to own a bicycle. On this day, they are forced to exchange textile coupons from their rations in order to wear a mandatory yellow star with the word *Juif*.

By pulling back, you begin to see in a panoptic way what's going on. And I would never want to put any fictive reimagining onto those events because that would be a trespass into history, if that makes sense.

AM It's an immensely painful history, but your writing emanates with warmth, curiosity, and empathy. What was it like for you to research this history when preparing for your earlier book, *The Hare with Amber Eyes*? That is the story of your family, told by tracing the history of a collection of netsuke—lovely, small sculptural objects that fit in the palm of your hand—that was passed down through your family, hidden inside a mattress during the war, and that at one point belonged to you. What prompted you to follow the journey of this collection, and what mysteries did you uncover along the way?

EDW That book was driven by the experience of having these objects, the netsuke, at home. My children were young, and my father was getting older. And I was wondering how to get my father, who hasn't talked about what went on, and hasn't talked about his childhood—who doesn't feel that there's anything to talk about—how to get him to talk. I needed him to talk. So, it was a personal decision. It wasn't a commissioned book. No one asked me to stop making pots and to instead spend years researching in dusty archives or studying for hours in the middle of the night. It started before the Internet as well. So I would persuade my wife to let me go off to Paris for a week here and a week there.

But the impetus, the absolute crucible, was this feeling of urgency—that I had to write something while my dad was still alive. I had to get him to be part of this project. And he would always say, "Well, there isn't anything." But then he would produce a few envelopes, and then he would produce another thing. And now, at ninety-five, he's still producing another envelope, another story.

AM Your approach was so modest. You're looking for a family history, a family story. In the end, what

Musée Nissim de Camondo, Paris

you've written is so much more than that. Did *The Hare with Amber Eyes* transform your relationship with your father? Did it transform his relationship with his past?

EDW It did. On October 20, 2011, *The Hare with Amber Eyes* was published in German, in Vienna. And that evening I presented the book in the old Palais Ephrussi. It was the first time our family had been back in that house. I stood up and gave a speech about what restitution really means. I said, "We're not waiting for paintings. We're not waiting for property. That's not the point. The point is, I am restituting our family back to our home. I am restituting a story and a family back. The agency is with us, and we are not waiting for anyone else to do it." That night my dad was there. And Jiro, my great-uncle Iggie's lovely partner, was there. My daughter wasn't there, she was too young, but my father took my boys by the hand and brought them to see his old bedroom. This is the man who said, "I don't remember anything about Vienna." At that moment you think, that's the point. That's why you write a book. Because memories are a hugely powerful thing.

AM I think your writing has made an emotional impact on many people. That must have been surprising.

EDW Of course. I am in a state of constant surprise. Grateful surprise.

AM After writing *The Hare with Amber Eyes*, were there parallels you felt connected you to Camondo, who was not a member of your family? Why did you feel compelled to tell his story?

EDW Well, even having finished *The Hare with Amber Eyes*, it's an unfinished story. And with your questions about the 1940s, it's so important to remember that there is no single story, and there's no closure in the story.

As for Camondo specifically, he tries to make the house and everything in it a memorial for his son [who died in World War I] and his father, something that holds his name, that will survive, and he gives it to France. It's to be this perfect encapsulation of culture, an assimilation of French civility. But it totally fails. The family is murdered by the French state, by their neighbors. They are deported and murdered in Auschwitz. And this memorial sits there as a question about what memorial means. What are you trying to hold within a memorial? What are you trying to project forward into the future? Camondo is saying, "This is where we belong. This is our family. This is our name. This is our relationship with our community, with France, and with French culture." And that's torn up, but the house remains. It was compelling for me to engage with that. As a writer and an artist, I am endlessly trying to work out what memory means, and what a memorial might mean. How could I not want to cross that threshold?

AM After the book was published, you were invited to exhibit your work in the Musée Nissim de Camondo, the former residence of Count Moïse de Camondo. What was that like?

EDW That was an extraordinary invitation. And it was a really difficult project. Nothing had been moved in the house, so I was grappling with how I could bring something in, and in the end I made things that sat very lightly within the house. I hid works in the attic, the cupboards, the drawers. There were broken objects, shards, and letters placed within these spaces, which almost felt forgotten. It felt like I was reinhabiting the archive, putting something back into those spaces. But it was a very emotional thing to work out what to do.

AM Your family lost a famous library during the looting in Vienna. And you have incorporated libraries, books, poetry, and writing into your work as a visual artist. Would you comment on why books are often some of the first vessels of culture that are destroyed when political power structures shift?

EDW It's no surprise that over the last two thousand years so many libraries have been destroyed. Basically, by holy men of every persuasion. And by people who want to shut down the danger, the beautiful danger, that's present in libraries. Books are profoundly dissenting. They are polyphonic, multivocal. They amplify voices of the dispossessed, voices that are otherwise quiet, voices that are trying to explore domestic, smaller, complex, familial stories, or voices grappling with larger histories. So of course people want to burn libraries down. They want to loot them. They want to edit them. They want to redact them. You see it across history.

AM When you think about periods of history, such as the 1940s, and compare it with the challenges we are facing today . . .

EDW There is so much at stake. There was so much at stake then, and in the extraordinarily painful position of postwar Europe, with millions of displaced people trying to find where they belonged, where they would be welcomed, what borders to cross, how to make communities work. And you think about now, and the rise of the language of control, about borders and people, and migrations and languages. How can I not want those to be part of what I make and what I write?

AM During the 1940s, so much was lost in the destruction of the war. I wonder if you have any thoughts about lost histories and the inherent power in the stories that we carry forward, versus those that we move on without, and the ways history gets written.

EDW In *Letters to Camondo* there is a quote from Jean Améry: "I do not have clarity today, and I hope that I never will. Clarification would amount to disposal, settlement of the case, which can then be placed in the files of history . . . nothing is resolved, nothing is settled, no remembering has become mere memory." I feel this is true. We can never recover all the stories. We can never recover all the families, all the extraordinary, beautiful intensity of those lost, lived lives.

Edmund de Waal is an internationally acclaimed author and visual artist who uses objects as vehicles for human narrative, emotion, and history.

Alison McDonald is the Chief Creative Officer at Gagosian and has overseen marketing and publications at the gallery since 2002.

NOTES

PAGES 2–5, "A LOOK AT THE 1940s": 1 Fiske Kimball, *Sixty-Sixth Annual Report of the Philadelphia Museum of Art* (1942), 29. **2** Kimball, *Sixty-Sixth Annual Report*, 29–30. **3** Other installations ranged from *French Silver of the Old Regime: The Helft Collection* to *Life in Philadelphia: An Exhibition in Conjunction with the Bicentennial Celebration of the University of Pennsylvania*. **4** Carl Zigrosser and Christian Brinton, "Contemporary Russian Graphic Art," *Philadelphia Museum Bulletin* 37, no. 191 (November 1941): n.p. **5** Kristen A. Regina, "The Christian Brinton Library and Archives at the Philadelphia Museum of Art," *Slavic & East European Information Resources* 23, no. 4 (2022): 375–91, doi.org/10.1080/15228886.2022.2105190. **6** A. E. Gallatin, "The Plan of the Museum of Living Art" (1940), in *A. E. Gallatin Collection* (Philadelphia Museum of Art, 1954), 5. **7** Henry Clifford, "The Gallatin Collection . . . Mirror of Our Time," *Philadelphia Museum Bulletin* 38, no. 198 (May 1943): n.p. The more than 160 objects became a permanent part of the collection after Gallatin's death in 1952. **8** See p. 80 below, and Edward Warwick, "Report of the Dean of the Art School to the President and Trustees," *Seventieth Annual Report of the Philadelphia Museum of Art* (1946), 37. **9** Carl Zigrosser, "Japanese Prints," *Philadelphia Museum Bulletin* 42, no. 211 (November 1946): 3–5. **10** Quoted in *Treasures of Asian Art: A Rockefeller Legacy*, Asia Society Texas Center, Houston, April 14, 2012–October 7, 2012, asiasociety.org/texas/exhibitions/treasures-asian-art-rockefeller-legacy. **11** Fiske Kimball, "Museums Abroad Since the War," *Philadelphia Museum Bulletin* 44, no. 219 (November 1948): 3. **12** Edward Warwick, "The Report of the Dean of the Art School," *Sixty-Seventh Annual Report of the Philadelphia Museum of Art* (1943), 39. **PAGES 6–7, "WITNESS TO THE WAR": 1** Margaret Bourke-White, *Portrait of Myself* (Simon and Schuster, 1963), 174. **2** Margaret Bourke-White, *Shooting the Russian War* (Simon and Schuster, 1943), 23. **3** Bourke-White, *Shooting the Russian War*, 171. **4** Peter Kort Zegers, "Storied Windows," in *Windows on the War: Soviet TASS Posters at Home and Abroad, 1941–1945*, ed. Zegers and Douglas Druick (Art Institute of Chicago, 2011), 214. **5** "Moscow Fights Off Nazi Bombers and Prepares for a Long War," *Life*, September 1, 1941, 16–17. **PAGES 14–15, "'NEEDLES AND GUNS'": 1** Elsa Schiaparelli, *Shocking Life* (E. P. Dutton, 1954), 132. **2** Kathleen Cannell, "Paris Sees Change in World Fashions," *New York Times*, October 30, 1939, 14. **3** "Schiaparelli—via Clipper," *Vogue*, January 15, 1940, 73. **4** Elsa Schiaparelli, "Needles and Guns," *Vogue*, September 1, 1940, 57. **PAGES 16–25, "THE POEMS OF ANNA AKHMATOVA": 1** For biographical and other information on Akhmatova and her work, as well as the selected poems reproduced here, I have relied on Roberta Reeder, ed., *The Complete Poems of Anna Akhmatova*, trans. Judith Hemschemeyer (Zephyr Press, 2021). **PAGES 26–27, "UNSEEABLE THINGS": 1** Weegee [Arthur Fellig], *Weegee's Creative Camera* (Hanover House, 1959), 100. **2** Walter Clark, *Photography by Infrared: Its Principles and Applications* (John Wiley and Sons, 1946), 323. **3** Christopher Bonanos, *Flash: The Making of Weegee the Famous* (Henry Holt, 2018), 159; and Weegee, *Weegee's Creative Camera*, 98. **4** Weegee, *Weegee's Creative Camera*, 99. **5** James Elkins, "Harold Edgerton's Rapatronic Photographs of Atomic Tests," *History of Photography* 28, no. 1 (2004): 76–78. **6** Richard F. Dempewolff, "Pictures That Freeze Time," *Popular Mechanics* 114, no. 2 (August 1960): 66–71. **PAGES 32–33, "ART IN THE HOME": 1** Quoted in Valerie D. Mendez, *Ascher: Fabric, Art, Fashion* (Victoria and Albert Museum, 1987), 60. **2** Mary Roche, "6 Artists Turn Out Brilliant Group of Fabric Prints in Modern Style," *New York Times*, June 22, 1949. **3** Dilys Blum, *Shocking! The Art and Fashion of Elsa Schiaparelli* (Philadelphia Museum of Art, 2003), 130–33. **PAGES 34–35, "MAKE IT DO": 1** President Calvin Coolidge is credited with popularizing this expression, published in the *Handbook for the United States Citizens Service Corp* (1942) and taken up by the War Advertising Council. **2** Alexander S. C. Rower and Holton Rower, eds., *Calder Jewelry* (Calder Foundation, 2007), 51. **3** The brooch appears as design no. 18, annotated as "Spirals—brooches brass 12.00," in the drawings in Calder's jewelry inventory book of about 1941. For additional examples, including an inventory drawing for his 1946 exhibition at Galerie Louis Carré, Paris, see Rower and Rower, *Calder Jewelry*, 151, fig. 43, 258. **4** Shelley Selim, ed., *Bent, Cast & Forged: The Jewelry of Harry Bertoia* (Cranbrook Art Museum, 2015), 22. **5** Anne Allman, "Biography of Elsie Marie Bates-Freund," typescript, Louis and Elsie Freund Papers, 1945–1994, Special Collections, College of the Ozarks, Point Lookout, MO. **6** Freund sold more than 10,000 works from the Sea Chantey, owned by Jane Hersey. Allman, "Biography of Elsie Marie Bates-Freund," n.p. **PAGES 36–43, "QUEER CONNECTIVITY": 1** Catalog: Delaney, Beauford, Galerie Darthea Speyer, Paris, France, 1973 February 6–March 2, ms_3967.VI.A.29.1.12, box 29, folder 1, item 12, Beauford Delaney Papers, MS-3967, Betsey B. Creekmore Special Collections and University Archives, University of Tennessee, Knoxville. **2** Peter Barr, "The Reception and Sources of Berenice Abbott's Paris Portrait Style, 1925–1929," *History of Photography* 34, no. 1 (2010): 43–59, esp. 51. **3** George Biddle, *The Yes and No of Contemporary Art: An Artist's Evaluation* (Harvard University Press, 1957), 124. **PAGES 44–45, "FROM WAR TO PEACE": 1** Anne Monahan, *Horace Pippin: American Modern* (Yale University Press, 2020), 43. **2** Edward Puchner, "Winning the Peace over Mr. Prejudice: Horace Pippin, the Social Gospel, and the Double V," in *Horace Pippin: The Way I See It*," ed. Audrey Lewis (Brandywine River Museum of Art, 2015), 64. **3** On June 25, 1941, President Franklin D. Roosevelt issued Executive Order 8802 to prohibit discrimination in the defense industry and government based on race, color, creed, or national origin. **4** Puchner, "Winning the Peace," 65–67. **5** While white squirrels are rare, residents in the area have confirmed their presence with photo documentation. **6** Romare Bearden, *Horace Pippin* (Phillips Collection, 1976). **PAGES 46–55, "FASHION DURING WARTIME": 1** Irene Guenther, *Nazi Chic? Fashioning Women in the Third Reich* (Berg, 2004), 144. **2** "What America Imported from the Paris Openings," *Vogue*, October 1, 1939, 51. **3** Bettina Wilson, "Paris Life—Under Arms," *Vogue*, October 15, 1939, 111. **4** Julie Summers, *Fashion on the Ration: Style in the Second World War* (Profile Books, 2015), 62. **5** *Federal Register* 7, no. 70 (April 10, 1942): 2722, www.govinfo.gov/content/pkg/FR-1942-04-10/pdf/FR-1942-04-10.pdf. **6** "Swim Suits to Parachutes," *Harper's Bazaar*, September 1943, 119. **7** "What Can I Do," *Harper's Bazaar*, July 1940, 32 [capitalization standardized]. **8** "Red Cross Produces 3,102,072 Articles," *New York Times*, May 16, 1943. **9** "Vogue's Eye View: American Fashion Openings," *Vogue*, September 1, 1940, 41. **10** "A New Hand in the American Couture," *Vogue*, March 15, 1942, 62. **11** The murals were in a mansion at 813 Fifth Avenue that was open to the public April 7–14, 1946. **12** Valerie Steele, "Women Fashioning American Fashion," in *Women Designers in the USA, 1900–2000: Diversity and Difference*, ed. Pat Kirkham (Yale University Press, 2000), 187. **PAGES 56–57, "GEORGE NAKASHIMA": 1** Viewing those of Japanese ancestry as threats to national security, the US government instituted mass incarceration of over 122,000 people of Japanese descent, resulting in the loss of their property, businesses, and livelihoods. Detained at ten sites in seven states—Arkansas, Arizona, California, Colorado, Idaho, Utah, and Wyoming—70,000 of these evacuees were American citizens. "Executive Order 9066: Resulting in Japanese-American Incarceration (1942)," National Archives, www.archives.gov/milestone-documents/executive-order-9066. **2** Brian Niiya, "Minidoka," *Densho Encyclopedia*, encyclopedia.densho.org/Minidoka/. **3** See David Lane, "Gentaro Kenneth Hikogawa," *Densho Encyclopedia*, encyclopedia.densho.org/gentaro_kenneth_hikogawa. Nakashima practiced architectural design in Pondicherry, India, from 1937 to 1939; from 1941 to 1942 he lived and had a business in Seattle "designing and constructing furniture." George Katsutoshi Nakashima, Application for Employment, Biographical Statement, Seattle Office, American Friends Service Committee [AFSC], March 29, 1943; see 1943, Social Industrial Section, Japanese-American Relocation, Individuals—George Nakashima, AFSC Archives, Philadelphia. **4** Floyd Schmoe, AFSC Seattle, to Homer L. Morris, AFSC Philadelphia, March 26, 1943; see 1943, Social Industrial Section, Japanese-American Relocation, Individuals—George Nakashima, AFSC Archives, Philadelphia. **5** George Nakashima to René d'Harnoncourt, February 15, 1944, René d'Hanoncourt Papers (RdHP), III.4, Museum of Modern Art, New York. **6** Nakashima to d'Harnoncourt, April 19, May 6, May 8, and August 27, 1944, RdHP, III.4. **7** Nakashima to d'Harnoncourt, November 2, 1944, RdHP, III.4. **8** Nakashima to d'Harnoncourt, February 15, 1944, RdHP, III.4. **9** The design for the straight-back chair appears in his first catalogue, dated 1945, as "E Straight Chair." See Mira Nakashima, *Nature, Form & Spirit: The Life and Legacy of George Nakashima* (Harry N. Abrams, 2003), 80. **10** Nakashima, *Nature, Form & Spirit*, 41. **11** Nakashima, *Nature, Form & Spirit*, 41. **PAGES 64–65, "GENESIS": 1** Krasner described visiting Pollock's studio for the first time late in 1941, and being angry at herself for not already knowing his work. Francine du Plessix and Cleve Gray, "Who Was Jackson Pollock?," *Art in America* 55, no. 3 (May–June 1967): 48–51. **2** For overviews of the "Little Image" series, see Ellen G. Landau, *Lee Krasner: A Catalogue Raisonné* (Harry N. Abrams, 1995), 100–116, and Eleanor Nairne, ed., *Lee Krasner: Living Colour* (Thames & Hudson, 2019), 82–95. **PAGES 66–75, "THE ECONOMIES OF WAR": 1** Gross domestic product (GDP) in England, Our World in Data, ourworldindata.org/grapher/total-gdp-in-the-uk-since-1270. **2** Simon Partner, "The WW II Home Front in Japan," Duke University Opinion and Analysis, March 20, 2003, today.duke.edu/2003/03/japan_lecture0321.html. **3** "Research Starters: US Military by the Numbers," National WWII Museum, New Orleans, www.nationalww2museum.org/students-teachers/student-resources/research-starters/research-starters-us-military-numbers. **4** See Evan K. Rose, "The Rise and Fall of Female Labor Force Participation During World War II in the United States," *Journal of Economic History* 78, no. 3 (September 2018): 673–711, doi.org/10.1017/S0022050718000323; and "Women's World War II Achievements Remembered Ahead of Anniversary, www.dla.mil/About-DLA/News/News-Article-View/Article/2136298/womens-world-war-ii-achievements-remembered-ahead-of-anniversary/. **5** De Havilland D.H. 106 Comet Mk. 4C, The Museum of Flight, Seattle, www.museumofflight.org/exhibits-and-events/aircraft/de-havilland-dh-106-comet-mk-4c. The Lockheed Electra in the United States experienced similar problems. **6** See David R. Henderson, "The U.S. Postwar Miracle," Mercatus Center, George Mason University, Working Paper No. 10-67 (2010–11), hdl.handle.net/10945/43115; and *Administrator of Veteran Affairs Annual Report for Fiscal Year Ending June 30, 1947* (Veterans Administration, 1948), p. 57, www.va.gov/vetdata/docs/FY1947.pdf. **PAGE 80: 1** Marion Lawrence, "The Importance of College Art Courses in the Present Emergency," *College Art Journal* 2, no. 4 (May 1943): 103, doi.org/10.1080/15436322.1943.10794980; written when Lawrence was chair of the Art Department at Barnard College. The full first sentence (with original punctuation), excerpted above, is: "It was demonstrated in England that the greater the strain of war work, anxiety, and hardship, the greater the demand for music, art and literature."

IMAGE CREDITS

Medium and dimensions are provided for works in the Philadelphia Museum of Art's collection.

PAGES 2–5, "A LOOK AT THE 1940s": **1** Collection of Jessica Smith; **2** Oil on canvas, 47 × 33 in. (119.4 × 83.8 cm), Philadelphia Museum of Art [hereafter PMA]: The Henry P. McIlhenny Collection in memory of Frances P. McIlhenny, 1986-26-38; **3** Oil on canvas, 49 15/16 × 40 1/8 in. (126.8 × 101.9 cm), PMA: Gift of Christian Brinton, 1941-79-335; **4** PMA Library and Archives; **5** PMA Library and Archives; **6** PMA, A. E. Gallatin Archives; **7** PMA Library and Archives; **8** Pen and black ink with traces of graphite on paper, 10 1/2 × 14 in. (26.7 × 35.6 cm), PMA: Gift of Lessing J. Rosenwald, 1965-188-1 © The Bendiner Foundation–Ms. Rachel Chasin, Administrator. Reproduced by permission. **PAGES 6–7, "WITNESS TO THE WAR"**: Color stencil print, 85 × 46 in. (215.9 × 116.8 cm), PMA: Gift of the American Russian Institute, 1945-8-3; Gelatin silver print, 9 3/4 × 13 1/4 in. (24.8 × 33.7 cm), PMA: Purchased with funds contributed by David and Becky Gottlieb in memory of Drs. Harry and Betty Gottlieb, 2024-83-1, Margaret Bourke-White/The LIFE Picture Collection © Meredith Corporation. **PAGES 8–13, "THE WAR"**: National Archives, Washington, DC. **PAGES 14–15, "'NEEDLES AND GUNS'"**: Rayon crinkle crepe, silk crepe, gilded metallic thread embroidery, PMA: Gift of Mme Elsa Schiaparelli, 1969-232-71a,b; Black rayon crepe, magenta cellulose acetate velvet with silk embroidery, PMA: Gift of Mme Elsa Schiaparelli, 1969-232-17; Photo © Condé Nast via Getty Images. **PAGE 16–25, "THE POEMS OF ANNA AKHMATOVA"**: Photo © Fine Art Images / Bridgeman Images; akg images / Elizaveta Becker. **PAGES 26–27, "UNSEEABLE THINGS"**: Gelatin silver print, 9 3/4 × 12 1/4 in. (24.8 × 31.1 cm), PMA: Gift of Robert Yoskowitz, 2023-170-2 © International Center of Photography/Getty Images; Gelatin silver print, image 18 1/16 × 14 5/16 in. (45.8 × 36.3 cm), PMA: Gift of The Harold and Esther Edgerton Family Foundation, 1996-75-43 © Harold Edgerton. **PAGES 28–31, "CULTURAL RENEGADES"**: Margaret Bourke-White/The LIFE Picture Collection © Meredith Corporation; William P. Gottlieb/Ira and Leonore S. Gershwin Fund Collection, Music Division, Library of Congress; © Michael Ochs Archives/Getty Images; © Allan Grant/The LIFE Picture Collection/Shutterstock; © Allan Grant/The LIFE Picture Collection/Shutterstock. **PAGES 32–33, "ART IN THE HOME"**: National Portrait Gallery, London, NPG x195116 © National Portrait Gallery; Screenprint on silk, 43 × 36 5/8 in. (109.2 × 93 cm), PMA: Purchased with funds contributed by an anonymous donor, 1989-74-3, Barbara Hepworth © Bowness; Printed cotton and rayon blend plain weave, 9 feet 2 in. × 48 1/2 in. (279.4 × 123.2 cm), PMA: Purchased with the Costume and Textiles Revolving Fund, 2018-13-1 © 2024 Salvador Dalí, Fundació Gala-Salvador Dalí, Artists Rights Society (ARS), New York. **PAGES 34–35, "MAKE IT DO"**: Copper sheet, copper round wire, fused clay and glass, 3 × 1 1/8 × 11 in. (7.6 × 2.9 × 27.9 cm), PMA: Gift of the artist, 1991-107-1; Silver electroplated with gold, 3 1/2 × 4 in. (8.9 × 10.2 cm), PMA: Gift of Frances Elliot Storey and Gay Elliot Scott, 2014-10-2; Brass, steel wire, 4 1/4 × 3 3/16 in. (10.8 × 8.1 cm), PMA: Gift of Jane Goldstone Hilles in memory of her parents, John Lewis and Jeannette Kilham Goldstone, 2011-94-2 © 2024 Calder Foundation, New York / Artists Rights Society (ARS), New York; Gelatin silver print, 9 1/2 × 7 3/16 in. (24.1 × 18.3 cm), PMA: Gift of John Mark Lutz, 1965-86-7655. **PAGE 36-43, "QUEER CONNECTIVITY"**: **1** Graphite and white opaque watercolor on light brown wove paper, 23 5/8 × 33 1/2 in. (60 × 85.1 cm), PMA: Purchased with funds contributed by C. K. Williams, II, 2013-75-1; **2** Oil on canvas, 22 × 18 in. (55.9 × 45.7 cm), PMA: 125th Anniversary Acquisition. Purchased with funds contributed by The Daniel W. Dietrich Foundation in memory of Joseph C. Bailey and with a grant from The Judith Rothschild Foundation, 1998-3-1 © 2024 Estate of Beauford Delaney, by permission of Derek L. Spratley, Esquire, Court Appointed Administrator. Courtesy of Michael Rosenfeld Gallery LLC, New York; **3** Charcoal with stumping and erasing on paper, 24 3/4 × 18 5/8 in. (62.9 × 47.3 cm), PMA: 125th Anniversary Acquisition. Purchased with funds contributed by Marion Boulton Stroud, with the gift (by exchange) of Dr. and Mrs. Paul Todd Makler, and gift of The Georgia O'Keeffe Foundation, 1997-41-1 © 2024 Georgia O'Keeffe Museum/Artists Rights Society (ARS), New York; **4** Gelatin silver print, 9 7/16 × 6 9/16 in. (24 × 16.6 cm), PMA: Gift of John Mark Lutz, 1965-86-2084; **5** Gelatin silver print, 9 7/8 × 6 3/8 in. (25.1 × 16.2 cm), PMA: Gift of John Mark Lutz, 1965-86-2077; **6** Carl Van Vechten Papers, Yale Collection of American Literature, Beinecke Rare Book and Manuscript Library, Yale University, New Haven, YCAL MSS 1050 © The Romaine Brooks Estate - Pascal Alcan Legrand; **7** Gelatin silver print, 9 5/8 × 7 1/4 in. (24.5 × 18.4 cm), PMA: Gift of John Mark Lutz, 1965-86-2180; **8** Gelatin silver print, 9 15/16 × 7 1/2 in. (25.2 × 19 cm), PMA: Gift of John Mark Lutz, 1965-86-1446; **9** Clark Art Institute: Gift of A&M Penn Photography Foundation by Arthur Stephen Penn and Paul Katz, 2007.2.218 © Berenice Abbott / Commerce Graphics Ltd. Inc.; **10** Gelatin silver print, 7 7/16 × 9 3/4 in. (18.9 × 24.8 cm), PMA: Gift of C. K. Williams, II, 2002-61-1 © Man Ray 2015 Trust/Artists Rights Society (ARS), NY / ADAGP, Paris 2024; **11** Oil on canvas, 50 × 60 1/16 in. (127 × 152.6 cm), PMA: Gift of the artist, 1972-121-4 © Estate of George Biddle; **12** Gelatin silver print, toned, 9 7/16 × 7 3/16 in. (24 × 18.3 cm), PMA: Purchased with the Alfred Stieglitz Center Fund, 1989-84-1. Used with permission of The George Platt Lynes Estate; **13** Gelatin silver print, 9 3/16 × 7 7/16 in. (23.3 × 18.9 cm), PMA: Purchased with the Lola Downin Peck Fund, 2015-46-18. Used with permission of The George Platt Lynes Estate. **PAGES 44–45, "FROM WAR TO PEACE"**: Oil on canvas, 13 × 18 in. (33 × 45.7 cm), PMA: Bequest of Daniel W. Dietrich II, 2016-3-4; courtesy Pittsburgh Courier Archives; Oil on canvas, 18 1/8 × 14 1/8 in. (46 × 35.9 cm), PMA: Gift of Dr. and Mrs. Matthew T. Moore, 1984-108-1. **PAGES 46–55, "FASHION DURING WARTIME"**: Vogue © Condé Nast; Vogue © Condé Nast; Vogue © Condé Nast; Hagley Digital Archives; Cellulose acetate plain weave printed on both sides, PMA: Gift of Julia B. Leisenring in memory of Mrs. Alfred Bissell, 1994-111-2a,b; Printed silk twill, 35 1/2 × 35 1/2 in. (90.2 × 90.2 cm), PMA: Gift of John F. Platt, 1971-42-2; Farm Security Administration/Office of War Information Photograph Collection, Library of Congress Prints and Photographs Division; Official U.S. Navy Photographs, National Archives; Vogue © Condé Nast; VOGUE © Condé Nast; Vogue © Condé Nast. **PAGES 56–57, "GEORGE NAKASHIMA"**: Courtesy of the Nakashima Foundation for Peace, New Hope, PA; Walnut, 20 × 23 1/4 × 44 in. (50.8 × 59 × 111.8 cm), PMA: Gift of Anne d'Harnoncourt and Joseph Rishel, 2022-72-150; Walnut, grass, 29 × 26 1/2 × 20 in. (73.7 × 67.3 × 50.8 cm), PMA: Gift of Anne d'Harnoncourt, 2001-20-1. **PAGES 58-63, "HOLLYWOOD IN THE 1940s"**: Alamy Stock Photo; Alamy Stock Photo; Alamy Stock Photo; RKO/Kobal/Shutterstock; Wikimedia Commons © 1943 by Twentieth Century–Fox Film Corp; Collection of Steven Rea; Collection of Steven Rea. **PAGES 64–65 "GENESIS"**: Oil on canvas, 73 1/4 × 48 15/16 in. (186.1 × 124.3 cm), PMA: Gift of Mr. and Mrs. H. Gates Lloyd, 1974-232-1 © 2024 The Pollock-Krasner Foundation / Artists Rights Society (ARS), New York; Oil on canvas, 38 1/16 × 27 13/16 in. (96.7 × 70.6 cm), PMA: Gift of the Aaron E. Norman Fund, Inc., 1959-31-1 © 2024 The Pollock-Krasner Foundation / Artists Rights Society (ARS), New York; Archives of American Art, Smithsonian Institution, Washington, D.C. (DSI-AAA)8734 © 2024 The Pollock-Krasner Foundation (detail). **PAGES 66–75, "THE ECONOMIES OF WAR"**: **1** Screenprint, 15 1/8 × 13 in. (38.4 × 33 cm), PMA: Gift of John Frederick Lewis, Jr., 1944-42-1j © Estate of Hugo Gellert; **2** Photomechanical reproduction, 14 1/2 × 9 1/2 in. (36.8 × 24.1 cm), PMA: Gift of Major H. P. MacNeal, 1943-80-47; **3** The Detroit News, courtesy of The Detroit News Archive; **4** © The Associated Press/Charles Gorry **5** Courtesy of the Oregon Historical Society, Portland; **6** Photomechanical reproduction, 16 × 11 in. (40.6 × 27.9 cm), PMA: Gift of Dr. Herbert P. MacNeal, 1946-45-13; **7** Photomechanical reproduction, 15 × 10 in. (38.1 × 25.4 cm), PMA: Gift of Major H. P. MacNeal, 1943-80-16; **8** Photomechanical reproduction, 16 × 22 1/2 in. (40.6 × 57.2 cm), PMA: Museum Collection, 1970-28-148; **9** Color lithograph, 13 1/4 × 10 in. (33.7 × 25.4 cm), PMA: Gift of Dr. Herbert P. MacNeal, 1946-45-2. **PAGES 76–77, "FRAGMENTS OF LOST HISTORIES"**: © Dorling Kindersley Ltd / Alamy Stock Photo. **PAGE 80**: PMA, Library and Archives.

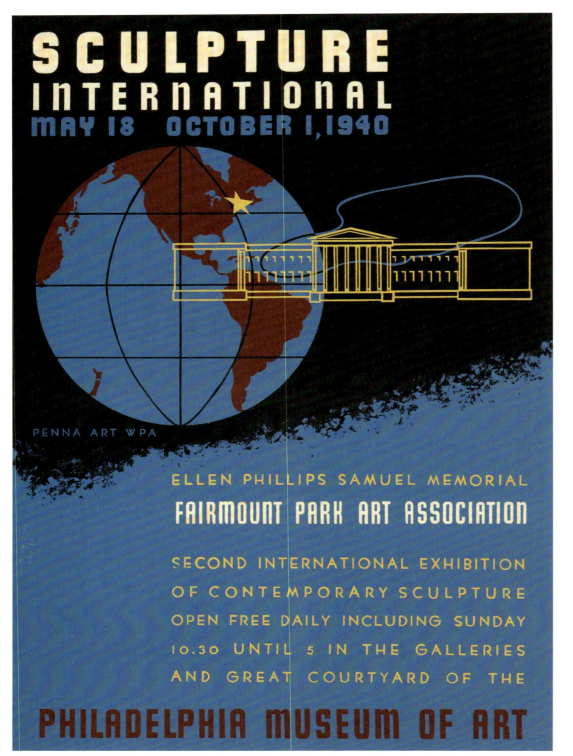

POSTER FOR THE SECOND SCULPTURE INTERNATIONAL AT THE PHILADELPHIA MUSEUM OF ART, 1940

The greater the strain of war work, anxiety, and hardship, the greater the demand for music, art and literature. Art is an escape to a saner, more balanced world from which one comes back fortified with keener imagination, a renewed sense of proportion and the tolerance given by historic perspective.

Marion Lawrence, 1943[1]

Acknowledgments

The Philadelphia Museum Art wishes to express our gratitude to all those from outside the institution who contributed their insights, talent, and expertise to this publication: Ken Burns, Vittoria Ciaraldi, Carole Courtillé, Edmund de Waal, Christian McBride, Frederic Murphy, Paul Neale, Alexandra Palmer, Steven Rea, and Isabella Szyfer, with special thanks to Alison McDonald, whose guidance made this project possible.

We also affirm our deep admiration for the many staff members, past and present, who were instrumental in bringing this publication and the related exhibition to fruition: Matthew Affron, Elisabeth Agro, Cindy Albertson, Aimee Almstead, Kathryn Babbs Miller, Yana Balson, Peter Barberie, David Barquist, Carlos Basualdo, Erica Battle, Jennifer Beatty, Marcia Birbilis, Lindsey Bloom, Dilys Blum, Amanda Bock, Richard Bonk, Gabriel Boyce, Luis Bravo, Katie Brennan, Sumner Bridenbaugh, Elizabeth Burke, Holly Chen, Ridge Chen, Alisa Chiles, Cathy Coho, Tara Contractor, Laura Coogan, James Coyne, Sarah Croop, Stephen Crouch, Kate Cuffari, Lauren David, Zachary Dell'Orto, Paul Dien, Kerry DiGiacomo, Jessica Donnelly, Gretchen Dykstra, Leslie Essoglou, Maggie Fairs, Colin Fanning, Emma Fee, Christopher Ferguson, Nancy Finn, Felice Fischer, Erin Florence, Kathleen Foster, Joshua Frank, Allison Freemond, Dave Gallagher, Laurel Garber, Michael Gibbons, Shakerra Grays, Eric Griffin, Josie Hall, Rylander Handford, Kristina Haugland, Chris Havlish, Kitty Bowe Hearty, Cathy Herbert, Sara Hernon-Reeves, Amy Hewitt, Jack Hinton, Rosalie Hooper, Audrey Hudson, Heather Hughes, Lauren Hunter, Aurielle Husband, Tim Jackson, Deric Johnson, Stephen Keever, Wynne Kettell, Hiromi Kinoshita, Kyoko Kinoshita, Alexandra Kirtley, Jeanine Kline, Rebecca Kolodziejczak, Paul Koneazny, Natalie Koziar, Kathleen Krattenmaker, Jane Lawson-Bell, Filiz Leigh, Teresa Lignelli, David Lincoln, Shivon Love, Sally Malenka, Louis Marchesano, Levi Martin, Eileen Matchett, Eric McDade, Zachary McKinney, Melissa Meighan, Sophia Meyers, Tatiana Michaels, Bree Midavaine, Dan Miller, Bernice Morris, Rebecca Murphy, Eleanor Nairne, Jocelyn Nesbit, Lindsey Nevin, Peggy Olley, Mia Paltrow-Murray, Tessa Paul, Neeraja Poddar, Tara Prakash, Thomas Primeau, Rona Razon, Kristen Regina, Sara Reiter, Erika Remmy, Imani Roach, Justin Romeo, Camila Rondon, Jay Roselius, Saralyn Rosenfield, Hiro Sakaguchi, Robert Schoenman, Lily Scott, Josephine Shea, Shen Shellenberger, Dan Shiman, Andrew Slavinskas, Jessica Smith, Carol Soltis, Sasha Suda, Ateret Sultan-Reisler, Christina Taylor, Bianca Thiruchittampalam, Jennifer Thompson, Joseph Troiani, Jordan Tucker, Mark Tucker, Alison Tufano, Kimberly Watson, Julie Weaver, Morgan Webb, Jeffrey Werner, Linnea West, Jason Wierzbicki, Hyunsoo Woo, Xiaojin Wu, and Rebecca Wui.